TREASURES OF THE ENGLISH CHURCH

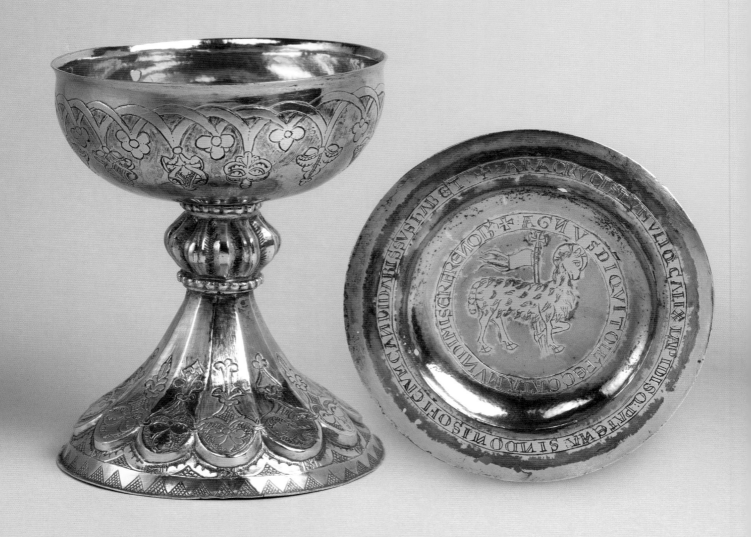

Archbishop Walter's chalice and paten, parcel-gilt, *c.* 1160 (Canterbury Cathedral)

TREASURES of the ENGLISH CHURCH

A Thousand Years of Sacred Gold and Silver

Edited by Timothy Schroder

Foreword by the Archbishop of Canterbury

The Goldsmiths' Company in association with Paul Holberton publishing

Contents

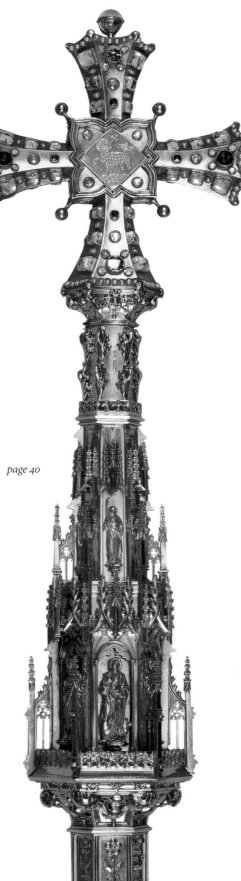

Fig. 1 The Primatial Cross of the See of Canterbury, silver-gilt and precious stones,
John Hardman (designed by Thomas Bodley), Birmingham, 1883 (Lambeth Palace)

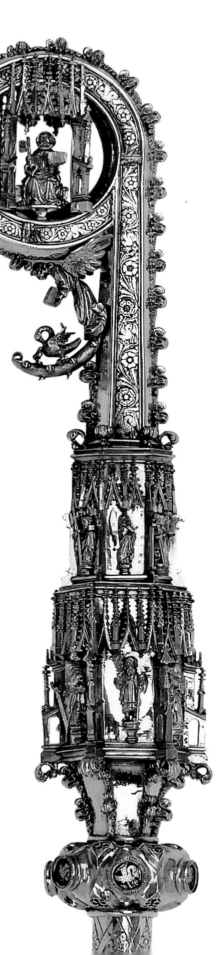

Fig. 2 Bishop Fox's crozier, silver-gilt and niello, *c.* 1500 (Corpus Christi College, Oxford)

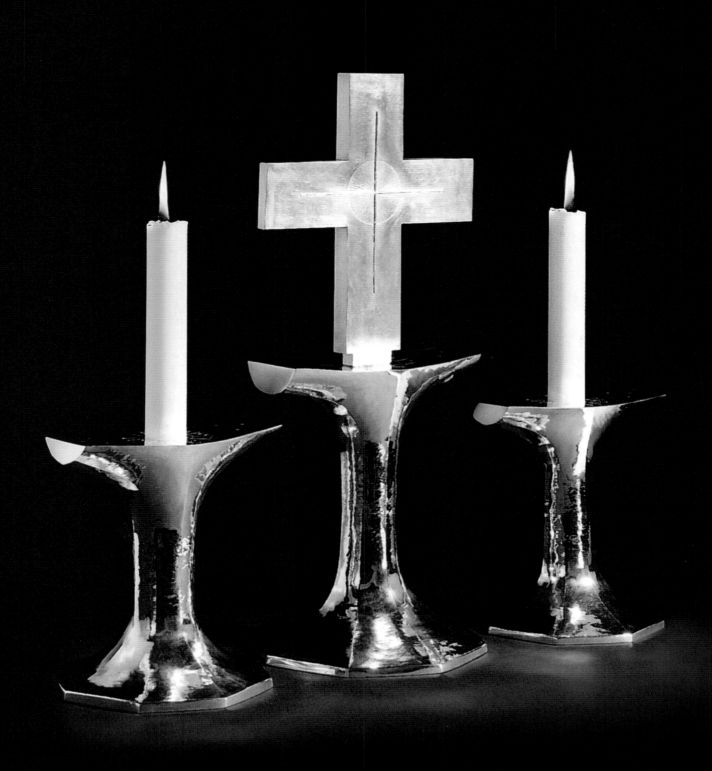

Fig. 3 Altar cross and candlesticks, silver, Michael Lloyd, 2000 (St Michael and All Angels, Steeple, Dorset)

Foreword

The Most Revd and Rt Hon Dr Rowan Williams, Archbishop of Canterbury

I am delighted to be the patron of this groundbreaking exhibition. There has been no major exhibition devoted to English church plate since 1955, when Christie's mounted a display in collaboration with the Historic Churches Preservation Trust. But that display concentrated on domestic objects donated to the Church, whereas this brings together for the first time as wide a range as possible of material designed for ecclesiastical use, from the ninth century to the present day, and is focused on plate that is still in use for its original purpose.

The Church has never been completely easy about the possession of extravagant liturgical objects. The great twelfth-century debate between St Bernard of Clairvaux and Abbot Suger of St Denis in Paris sets out the arguments: do riches distract the mind from the simple demands of the gospel and the need to be radically at the service of the poor? Or does the exuberance of skill and imagination itself display the overflowing extravagance of divine love, addressing human poverty at another level?

There has never been a simple answer to these questions; but we can at least say that the thousand years of craftsmanship represented here testifies to the passion so many have felt to put the very best they could do at the service of God. Despite all we hear about 'decline' in the Church or the alienation of people from traditional liturgy, it is striking how the tradition persists of commissioning beautiful objects for the Church's worship, and how ready the best craftsmen and artists still are – in this as in other areas – to offer their gifts at the altar.

The material collected here also tells us a good deal about the ups and downs of Church history. Style varies as the understanding of what is happening in worship changes: the pursuance of splendour as a vehicle for the sacramental presence of God in our midst gives way to a more sober post-Reformation idiom, seeking simple functional elegance for the gathering of believers at the Lord's Table; then restlessness about a functionalism that can become routine and prosaic produces in turn a reaction towards elaboration and intricacy, before the wheel goes round again towards simplicity.

Yet much of the plate in our churches is likely to be older than the actual buildings where it is housed; it is a mark of continuity as well as a sign of the shifts and reversals of history. This material symbolizes so much about the story of Christian faith in this country – often surrounded by controversy and uncertainty, sometimes unclear about how it should value its own traditions, yet persisting stubbornly in worship and witness, challenging the society around to integrity and excellence in all things – and ultimately to the celebration of an endless generosity in creation and redemption.

+ Rowan Cantuar:

Lambeth Palace, Corpus Christi, 22 May 2008

Introduction

Timothy Schroder

This book accompanies an exhibition organized by the Goldsmiths' Company and held at Goldsmiths' Hall in London in the summer of 2008. The exhibition draws on the precious metalwork of parish churches, cathedrals and other places of worship all over the country and is the largest and most comprehensive ever devoted to the subject. Some 300 objects from around 150 lenders and covering a thousand years of Church history are included, many of which are illustrated in these pages. But the items included in the exhibition are a tiny fraction of those owned by the Anglican and Roman Catholic churches and by other denominations in England. Taken as a whole they represent an extraordinary heritage, astonishing for its quantity but also for its historical reach and artistic breadth.

Whether as historians or casual visitors we are struck by many features of this great array of precious material. Perhaps the most striking of all is change, not only stylistic but in terms of form and repertoire. During its millennium and a half of continuous existence in this country the Church has seen many changes, some far-reaching and radical, violent even, and some less clamorous but with a theological significance that has had a powerful impact on outward appearances. All of these leave a visible trace in church plate. The revolutions of the mid sixteenth century left virtually no part of society unaffected and resulted in the greatest purge of devotional images and plate ever undertaken. The restoration of the altar as the centre and focus of worship in the seventeenth century led to a massive re-equipping of plate, sometimes on a vast and splendid scale. The spiritual regeneration that marked the High Church movement of the Victorian era gave rise to a new and rich visual language that deliberately evoked the supposed splendours of the medieval Church. The fragmentation of church communities over the centuries that was part of the legacy of Reformation and Restoration is also there to be seen in the different types of sacred vessels used by different denominations, from the distinctive forms associated with Roman Catholic worship to the homely domesticity of wares used by nonconformists, some of which were not made of precious metal at all.

But there is another thread running through all these movements and their associated plate, less immediately obvious but arguably more profound, and that is continuity. The Church may have changed its allegiance under Henry VIII from Pope to King, but it remained the Church, continuous and unbroken in its links to its past. And throughout all the swings of its history, throughout even its most violent and destructive phases, there has been a continuity of faith that is deeply imprinted in liturgical vessels. Medieval plate was not melted down out of mindless vandalism nor because people had become

irreligious. Quite the contrary. It was destroyed because it was perceived as distracting and idolatrous. The contrast between plain Elizabethan communion cups and sumptuous Victorian medieval revivals does not betoken greater or lesser religious commitment, just a different point of view.

There is a physical continuity in church plate too. The appearance and symbolism of Elizabethan communion cups may have been radically new and *dis*continuous but more often than not the actual metal of which it was made, melted down and refashioned, was the same. The whole purpose of changing chalices into communion cups in the sixteenth century was to forget, but sometimes plate made in the seventeenth or eighteenth century will carry an earlier inscription, transcribed from its recycled forerunner and preserving the memory of the original gift.

Giving, indeed, is the greatest continuity of all. Medieval shrines were built or augmented through the gifts of the faithful and some medieval chalices have inscriptions recording the names of their donors. The range of plate standing on the altar may have changed after the Reformation but the tradition of giving has continued right down to our own day, with pious parishioners and generous patrons commissioning new altar plate or giving domestic cups, dishes and flagons that were no longer needed at home. Sometimes in the past, no doubt, there was an element of self-promotion or political motivation to these gifts (it could be useful to be seen to be generous), but more often they were given in a spirit of humility and of community-mindedness and as a visible token of deeply held faith. The fact that we often know who the donors of these objects were and that they are still in regular use in the very place to which they were given hundreds of years ago makes a tangible bridge with the past in the collective memory of that place. Such objects and such inscriptions are powerful symbols of continuing community.

Curating an exhibition and editing a book simultaneously is not a task that can be undertaken without a good deal of help. I am most grateful to the Archbishop of Canterbury for kindly agreeing to be patron of the exhibition and to him and the Bishop of London for their thoughtful and thought-provoking contributions to this book; also to Jonathan Goodall, Chaplain to the Archbishop, for his constant support and encouragement. Paul Dyson and Eleni Bide at the Goldsmiths' Company and Laura Parker at Paul Holberton publishing worked tirelessly to procure photographs, many of which have been specially commissioned for this book. Elsewhere I am grateful to the following: Sophie Andreae, Margaret and Brian Baird, Rosemary Baird, the Bishop of Brentwood, Nigel Bumphrey, Lady Clifford, Sylvia Coppen-Gardner, Jeremy Garfield Davies, Mary Fewster, Jonathan Goodchild, Cynthia Harris, Tom Longford, Paul Micio, the Duke of Norfolk, the Hon. Dominic and Mrs Petre, Dr John Martin Robinson, Anthony Sale, James Stourton, Lord Talbot of Malahide and the staff of the Essex Record Office and Lambeth Palace Library.

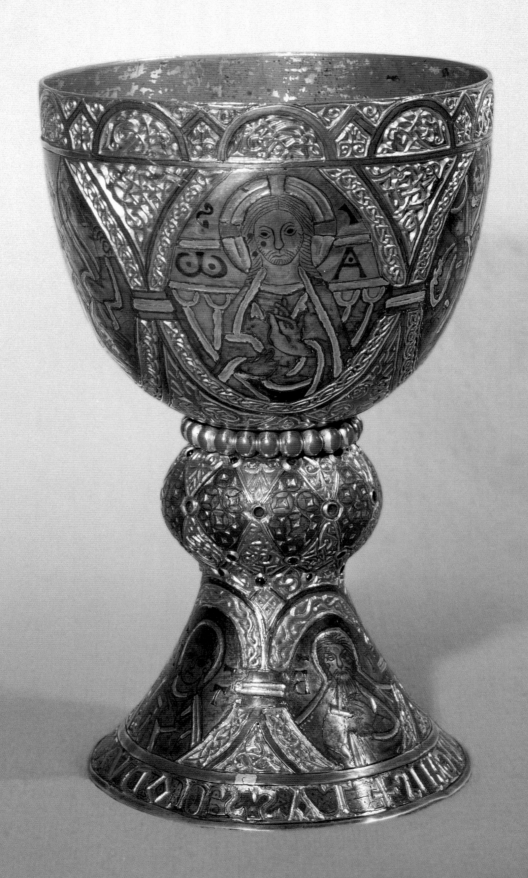

Saint Dunstan, Patron Saint of Goldsmiths

Douglas Dales

According to the records associated with the Goldsmiths' Company, St Dunstan (*c.* 909–988) was regarded as a patron of goldsmiths as early as 1273 (fig. 5). His reputation as a skilled metalworker was founded in fact and there may have been works of his still in existence at that time. William of Malmesbury, writing in the twelfth century, describes how Dunstan made organs and two notable bells for his monastery at Glastonbury, together with an altar cloth and a bell for the refectory, which had a dedicatory verse mentioning him by name. William further describes a similar range of gifts dedicated by Dunstan to St Aldhelm for use at the monastery at Malmesbury. Stories in the later lives of the saint, which tell of him tweaking the devil's nose with his metalworking tongs, have some root therefore in the historical memory of his prowess as a metal craftsman. In later medieval and modern tradition St Dunstan is often portrayed with tongs as his symbol.

Dunstan was born around the year 909 in the village of Baltonsborough near Glastonbury. He was educated there by Irish and English scholars and enrolled as a cleric and teacher. After some time he

Above: Fig. 5 *St Dunstan*, gilt wood, mid 18th century, originally the figurehead of the Company's barge (Goldsmiths' Company)

Facing page: Fig. 4 The Tassilo Chalice, bronze, gold and silver, late 8th century (Kremsmünster Abbey, Austria)

went to live at the court of King Athelstan and then, under the influence of his kinsman the Bishop of Winchester, he became a monk. Though there were no established monasteries in England at that time, owing to the inroads of the Viking invasions, there were contacts with the renewal of Benedictine monasticism on the Continent: the Archbishop of Canterbury, Oda, for example, had a personal link with the monastery of Fleury. In 942 Dunstan was appointed Abbot of Glastonbury, with the mission of creating a monastic community at the heart of what was already an ancient holy place and royal shrine. Many monks later went out from this community to recreate Benedictine monastic life throughout England in the second half of the tenth century under Dunstan's leadership.

Meanwhile Glastonbury grew rich with the benefactions of the king and the nobility. Some of their wealth was drawn from the mining of metals in the Mendips and Dartmoor, and William of Malmesbury gives a vivid picture of the generosity of King Edgar: 'He commissioned a cross to be placed above the high altar of interwoven gold and silver, along with some impressive small bells …. He also gave a large shrine, covered with gold and silver and decorated appropriately with ivory images.' None of Dunstan's own metalwork now remains; but it is possible that the famous picture associated with him in a Glastonbury book – *St Dunstan's Classbook*, now in the Bodleian Library – which shows him kneeling at the feet of Christ, was an outline for a work of metal relief, or perhaps for a fresco or a church vestment.

In 960 Dunstan became Archbishop of Canterbury, after a short exile in Flanders. He soon appointed his friend and fellow-monk Ethelwold to be Bishop of Winchester, in order to introduce monastic life to the cathedral there and also to the associated royal foundations of New Minster and Nunnaminster. In this enterprise they had the support of King Edgar and during the next twenty years almost two dozen monastic houses were founded, many of which lasted until the Reformation. Their ethos was defined in the *Regularis Concordia*, drawn up at Winchester in 973: this applied the Rule of St Benedict to English traditions, to create a uniform pattern of monastic life under the patronage of the king and queen.

Some of the most brilliant works of art that remain from this period sprang from the rich liturgical and spiritual life engendered by this monastic reform movement. Perhaps the most sensational example is the Benedictional of St Ethelwold, which he commissioned for his use as a bishop. It mirrors some of the rich gifts that he is known to have given to his monasteries at Abingdon and Peterborough. Ethelwold was very wealthy in his own right, and possibly a craftsman in metal as well: one of his most remarkable gifts to Abingdon was of a gold and silver *tabula supra altare*, enriched with figures of the twelve Apostles, which cost the vast sum of £300. Other gifts included three crosses in gold and silver, each larger than a metre, and a host of liturgical vessels.

It is a matter of regret that so little of Anglo-Saxon Church architecture or its accompanying

liturgical artefacts survives now. Yet the reputation of English craftsmen reached across the Continent, even as far as Rome itself. It was its material and artistic wealth that made the take-over of the English kingdom so attractive to the predatory Vikings and then to the Normans in the eleventh century. It may be assumed that the ecclesiastical artefacts that remain mirror equally rich work made for secular use, of which only fragments now exist. Elaborate metalwork, along with other artistic creations, was an important component in the liturgical life of this period, both royal and religious, endorsed by the practical expertise, example and generosity of leading monastic bishops and patrons like Dunstan and Ethelwold. In the Anglo-Saxon Church, art, ceremony, artefacts and belief were intimately associated and interdependent, in a manner associated today with Byzantine worship perpetuated in Orthodox Christianity, for example on Mount Athos.

St Dunstan's significance as a gifted Christian artist and craftsman needs to be seen, therefore, within the wider context of the monastic reform that he helped to lead; and this in turn was the culmination of a long tradition of brilliant metalwork that runs right through the Anglo-Saxon period, much of it associated with the life of the Church from its very beginning. After his death it became a standard expectation of priests that they should practise a craft.

The cross assumed a central place in the liturgical art of the Anglo-Saxons. Bede recounts in his *History* that St Augustine approached Canterbury in 597 in a procession, carrying a silver cross and an

Fig. 6 Pectoral cross, gold and glass, 7th century (Canterbury Museum)

icon of Christ. In the poem *The Dream of the Rood*, the cross appears 'clad in gold and shining gems, with five stones cross-wise at its heart'. On the Continent there remain two such crosses of later English metalwork, in Salzburg and in Brussels. From some of the earliest Anglo-Saxon graves of the seventh century emerge ornamental crosses, worked in gold and semi-precious stones, with an intricacy matched only in the jewellery of the Sutton Hoo ship burial (British Museum). The quality of this work is outstanding by the standards of any age. The most famous and lovely of such early crosses is the one found in the tomb of St Cuthbert (d. 687) in Durham Cathedral: it is made of gold, garnet, glass and shell, with dogtooth borders and cloisonné inlay. It was probably worn by the saint when he was Bishop of Lindisfarne. A similar cross was found at Canterbury (fig. 6).

Brooches were another treasured form of metalwork and, once again, the early burials of Kent have revealed some remarkable workmanship in

gold and silver. Evident in many of these artefacts are close links with Merovingian Gaul, the route by which Christianity came from Rome to southern England. From later in the Anglo-Saxon period – from the first part of the ninth century – six brooches in silver, intricately configured, were found at Pentney in Norfolk. Also from the ninth century comes the Strickland Brooch, made from silver with unusual gold inlay and decorated with zoomorphic forms. The most outstanding monument to the sophistication and skill of English metalwork in the late ninth century, however, is the Fuller Brooch, now in the British Museum. In hammered silver, inlaid with niello, it represents the Five Senses in human figures. It is a glimpse into the rich artistic world in which Dunstan grew up.

As English missionaries like St Willibrord and St Boniface took Christianity to the Low Countries and Germany in the eighth century, so craftsmen and scholars followed in their train. During the time of Charlemagne, the presence of Alcuin and others at his court ensured that cultural influence from England permeated Carolingian theology and art. Perhaps the most remarkable monument to this coalescence is the Tassilo Chalice at Kremsmünster in Austria (fig. 4). It dates from the late eighth century, sometime between the foundation of the monastery in 777 and the deposing by Charlemagne of its donor, Tassilo, Duke of Bavaria, in 788. It is large, almost 27 cm high, and can contain 1.75 litres of wine. Made out of gilded copper in two pieces, it is decorated with figures of Christ and the Evangelists supported by figures of St John the Baptist and

St Mary on the base. It is configured with interlace and zoomorphic forms and there is a cast inscription commemorating the donor and his wife. Comparable work of Anglo-Carolingian origin, from the first part of the ninth century, may be found in the elaborate Lindau Gospels cover, which is dominated by a jewelled Cross surrounded by intricate interlace patterning. This is now in the Pierpont Morgan Library in New York.

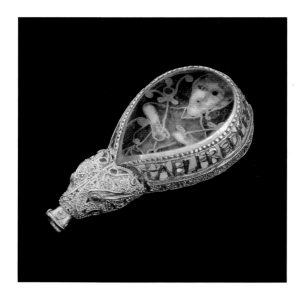

Fig. 7 The Alfred Jewel, gold, enamel and rock crystal, 9th century (Ashmolean Museum, Oxford)

Closer to the time and birth-place of St Dunstan, and closely associated with one of England's greatest kings, is the Alfred Jewel, now in the Ashmolean Museum in Oxford (fig. 7). It is comprised of a pear-shaped gold frame holding an enamel panel under a piece of clear rock-crystal. It is attached to a socket representing an animal head, and around the frame in open work runs the famous

inscription 'Alfred had me made'. It was found in 1693 near Athelney in Somerset, where Alfred tried to create a monastery to commemorate his victory over the Vikings in 878. Its iconography is subtle, possibly representing Christ as the Wisdom of God and giver of sight, with a Tree of Life inscribed on the back plate. It may have served as an 'aestel', the elaborate handle of a pointer for reading books, which Alfred himself describes.

Perhaps the closest link with the circle of St Dunstan is a portable sundial, found and preserved at Canterbury Cathedral, which probably dates from the later tenth century (fig. 8). It is a cast silver tablet, tapering towards the top end, engraved in three columns and perforated with suitably placed holes for the gnomon. The principles of its construction are described in a text, Byrhtferth's *Manual*, closely associated with the monastic reform movement of Dunstan and Ethelwold. This sundial measured time by the sun's altitude while hanging vertically down from its chain, which is still attached by an elaborate gold cap.

Most of the Anglo-Saxon metalwork that now remains attempted to capture and mirror the glory of God. Words from a ninth-century Northumbrian monastic poem, *De abbatibus*, articulate a vision of divine glory expressed in ecclesiastical art: 'The floor of the church building supported the weight of the many golden offerings placed on the table of miracle. A holy cross arose, resplendent on its lofty stem, dominating the table, glittering with bright emeralds. It blazed with golden plates, studded with dark-hued gemstones.'

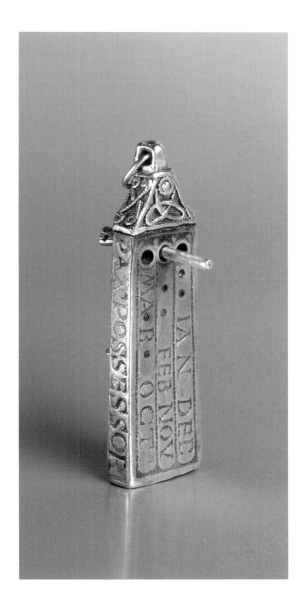

Fig. 8 Pocket sundial, silver, late 10th century (Canterbury Cathedral)

St Dunstan was remembered and revered as someone who expressed – by his sanctity and craftsmanship, derived from a long artistic tradition – the mystery of Christianity, encapsulated in the words of St Paul, 'Christ within you, the hope of glory to come.'

Fig. 9 Pax, silver, parcel-gilt, *c.* 1520 (New College, Oxford)

Church Plate before the Reformation

Clive Burgess and Marian Campbell

Part 1: The Church Universal? Paradox and Politics in medieval England
Clive Burgess

The period that dawned in the tenth century, in the aftermath of the Viking attacks, and that ended more abruptly in the 1530s and '40s presents a certain symmetry. Where the havoc wrought by the Vikings had caused the English kingdoms to turn in on themselves, by the tenth century the emergence of the West Saxon dynasty enabled a newly united England to renew diplomatic contacts with Continental courts. Moreover, from the reign of Edgar (r. 959–75), England pursued a policy of monastic renewal indebted to recent awakenings within the European Church. As a result, from the 970s, with the adoption of the Benedictine Rule within some of its larger and more influential communities, the English Church again began to take a more conformist place with its European neighbours. Such a development hastened the process whereby the English Church accommodated itself, during the course of the eleventh and twelfth centuries, with developing papal claims and within

a universal canon law, and submitted to and participated in new doctrinal and pastoral imperatives. England's Church and its clergy became subsumed within the jurisdictional and spiritual mainstream of Catholic Christendom. The Reformation of the mid-sixteenth century, however, sundered the English Church from 'universal practice'. After 1603 such developments set Christian practice and experience within Britain onto a path that differed from that maintained in most European realms, arguably with disastrous consequences for the monarchy in the short term. Nevertheless, the period from the tenth to the early sixteenth centuries witnessed the English Church taking its place and developing fruitfully within the Universal Church as an integral member of Catholic Christendom. Thereafter, insularity, reinforced now by a consciously national settlement, once again asserted itself.

This observation implies a number of points. First, as a realistic counterbalance to claims for

Fig. 10 Part of the Girdle of William of Wykeham, silver-gilt, precious stones and translucent enamel, 14th century (New College, Oxford)

increasing Catholicity in the high and late medieval period, it must be noted that ecclesiastical policy was ordinarily driven by secular authority and by political imperatives. Just as King Edgar began the process of monastic reform and personally sought to benefit from it, so, a century or more later, the accession of the Norman kings to the English throne furthered the processes of integration. The Conquest, while destructive in some respects, undoubtedly enabled England to participate more positively in the broader monastic developments afoot in Europe in the twelfth century. It arguably also eased the imposition of a universal Canon Law within England, and certainly exposed the English Church to pressures both for a more broadly enforced clerical celibacy and for more thoroughgoing educational provision. During the twelfth century it adjusted with some success to both of the latter imperatives. But King William and his successors were in practice wary of papal posturing, at best paying lip service to the grander claims emanating from Rome, and allowing the assimilation of their realm within papal obedience only insofar as it left royal authority to function much as it always had.

The second point is that it is wise to bear in mind that some national quirks would always remain. Institutionally, one might point to the situation, unique to England, where some cathedrals (like York Minster and St Paul's) remained secular communities whereas others (like Canterbury and Worcester) had become monastic. Stylistically, where architectural and decorative accomplishments were concerned, some developments – such as the 'perpendicular', flourishing in the fifteenth and early sixteenth centuries – remained very much an English phenomenon, gracing ecclesiastical and secular commissions alike.

Third, we need to remind ourselves – certainly in the light of opinion that judges the Anglican settlement as somehow inevitable and necessarily 'right' for England – that the Reformation proved a particularly destructive process. The great majority of the most ancient and prestigious institutions, in a Church hitherto institutionally rich, were quickly terminated by Acts of Parliament, and thereafter obliterated: this marked a brutal transformation. All that was left by the 1550s was a slightly increased number of cathedrals presiding over England's parishes; the latter, effectively the most recent institutional arrivals in the English Church, were also profoundly altered by the theological changes unleashed from the fourth decade of the sixteenth century. But hundreds of monasteries, nunneries, colleges, hospitals and almshouses were utterly lost: this was not, as some recent commentators have judged (presumably reckoning that the pastoral provision available in England was all that mattered), a Reformation that did not change very much. Institutionally, it amounted to devastation. Similarly, insofar as the liturgy was concerned – that all-important dialogue, perfected primarily in monasteries, whereby well regulated and seemly worship was offered to draw down the grace of God and which, in fifteenth-century England at least, was being progressively replicated in the local, parish churches – the upheaval was equally profound.

This leads to a fourth observation: the new dispensation did away with the need for elaborate equipment and array, along with a rich visual context of accompanying decoration and of an equal aural sophistication involving the widespread provision of complex music. The annihilation of institutions and an accompanying, radical reshaping of the liturgy meant that rituals that had previously depended upon elaborate vessels, vestments and regalia now needed not only much less, but also very different apparatus. This in its turn ensured the destruction, along with those larger institutions, of those accoutrements once deemed essential for the seemly and decorous celebration of the liturgy, but which would have decorated shrines and altars, or equipped bishops and abbots as well as more lowly celebrants. It is distressing to note how small a proportion of what once existed can now be mustered. In short, iconoclasm greatly accelerated and exacerbated the loss that would in any case have accrued with time and changing fashions. So much so, that very few gold or silver items now survive. The little that does often takes the form of founders' (usually bishops') regalia preserved in Oxford's colleges, which tended to be more conservative than their counterparts in Cambridge. The almost total loss of materials produced for monastic worship, which surely would have been among the most costly and elaborate of all, is a shortfall for which we now find ourselves hard pushed to make imaginative recompense. But, as a fifth point, it is only too easy – in the absence of survivals and when tending always to play safe and thus avoid assuming what seems to be

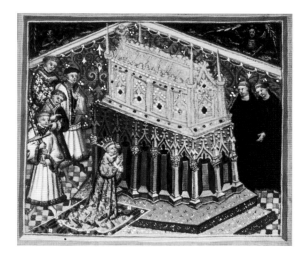

Fig. 11 Henry VI kneeling before the shrine of St Edmund, 1434 (from the *Life of St Edmund* by John Lydgate [d. *c*. 1451]) (British Library)

too much – to suppose that equipment in parish churches would probably have been very basic in the Middle Ages. While not insisting that parish provision had to be as ostentatious as that habitually employed in big institutions, 'safety first' assumptions may nevertheless prove particularly misleading where parish churches are concerned. Recent research, scrutinizing records and contemplating their shortcomings, plausibly suggests that local regimes might provide relatively lavish plate and equipment. This would have been a natural adjunct to the frequent rebuilding and sumptuous decoration of churches and to the evidently generous provision of priests at a time (after the advent of the Black Death) of relatively low population and high wealth. Anything less would have been nonsensical, given the outlay devoted to the churches on the one hand, and the importance assigned to decorous celebration on the other hand. It is, indeed, of the first importance to avoid falling into the trap, because so

little now survives, of assuming that contemporaries could never have had very much in the first place. But, having noted how little now survives, and the incorrect assumptions that such shortfalls can easily prompt, it is important by way of compensation to explore quite why contemporaries assigned such importance to finery, even in relatively lowly surroundings.

Finally, and as a result, we are obliged to confront a paradox, emerging perhaps most clearly from the implicit ambiguity in the first of the observations made above. While it may be true that the English Church became more thoroughly integrated with the practices and developments of the Church Universal from roughly the tenth century, it is important not to accept too much on trust. For so long as kings and their brothers in arms, the nobility, remained the main investors in and protectors of the Church in England, they expected the Church to deliver certain services, to the general benefit of the realm and of the shires. The generosity of the 'great and the good' is undeniable, but such men counted on the Church for essential assistance – paid for not by constant wages but by generous initial endowments (arguably a cheaper option in the longer term). Practically, the latter included help in governing the localities through bishops and abbots, whom the king might appoint in each generation. Spiritually, the support of the great and the good was intended to ensure that the liturgy be celebrated in as seemly a manner as possible, and as much as possible, to protect England from adversaries both seen and unseen. Governments insisted on maintaining a

basic control over the Church, whose services, practical no less than spiritual, proved constantly crucial. Hence the paradox of apparent ecclesiastical conformity with papal and canonical developments but, in practice, of determined royal control of key officers and institutions in a Church that reached (with unparalleled institutional tenacity, as elsewhere in Europe) into every parish pulpit. Kings and the nobility maintained a high level of investment in new ecclesiastical institutions for the benefit of the realm throughout the Middle Ages. Henry V founded both the Bridgettine nunnery of Syon and the Carthusian monastery at Sheen in the second decade of the fifteenth century, both of which were intended to function as an English Escorial *avant la lettre*, serving the nearby royal palace at Richmond. Henry VI followed suit, establishing Eton College in the 1440s, not so much as a school (although he did seek to mirror, and exceed, Bishop Wykeham's provision at Winchester), but more as a massive powerhouse of high-grade liturgy and prayer. When taken in combination with St George's College, Windsor, just a stone's throw away, to all intents and purposes these institutions constituted another Escorial – albeit staffed by canons, not monks and nuns – serving the great castle-palace on the Thames. Both kings were conscious of the imperative to 'increase Divine service' both by prayer and by liturgy, and (in their case) to advance the national cause in France. But what is particularly striking by the fifteenth century is how parishioners, too, invested in their local churches – by rebuilding, equipping priests, providing for extra stipendiaries, and by embellishing

church buildings and the standards of liturgical celebrations within them – similarly 'for the increase of Divine service'. Investment in the liturgy, and hence the Church, was undertaken throughout the realm as much for the national good, particularly in an age of protracted war, as for the good of the benefactors. Thus, it is striking how the subjects of the English crown, whether following royal and noble example or the bidding of their bishops, effected a and profound change within England. In many cases, piecemeal but consistent investment in parish regimes had, by the end of the fifteenth century, brought about a situation where erstwhile single-priest regimes were progressively resembling the larger and often more ancient liturgical communities that surrounded them, albeit still on a smaller scale. In short, such an impetus prompted the generous provision of plate and metalwork within churches both great and small, for prelates as well as for priests – although precious little now remains. So, while the English Church was still very definitely a component part of the Universal Church (for instance, taking an active part in solving the Schism at the Council of Constance), by the later Middle Ages the prevalent political theology within England was propelled by an undeniably nationalist agenda. Perhaps ironically, this had the effect of redoubling investment within the Church and its component parts and on its liturgy: splendour was of the essence. Patriotism and piety combined, in the period of ostensible 'universalism' preceding the Reformation, with remarkable and flamboyant success.

Part 2

Medieval Church Plate
Marian Campbell

Until the sixteenth century Roman Catholicism was the universal faith of the western world and Latin was its language. The Church and its benefactors were collectively the greatest patrons of the arts in medieval Europe, whether for cathedral, abbey, parish church or private chapel. Complex church rituals required a range of vessels, vestments, crosses and images. Gold, silver, precious and semi-precious stones, enamel, ivory and amber were the materials used by medieval craftsmen to make the sacred vessels used in the Mass. The glittering gold and silver altars and chalices used in its celebration were created not simply for their own beauty but for the greater glory of God. The precious materials symbolized the reverence due to God. Less wealthy churches were obliged to use baser materials like copper, brass and pewter for their vessels, and these tended to follow the style established by the goldsmiths.

Through the centuries, gold and silver – and indeed all metals – have been recycled many times and very little medieval goldsmiths' work has survived anywhere, least of all from England. Here the impact of the dissolution of the monasteries in the 1530s and the Reformation that followed resulted in a massive destruction of church plate, shrines and reliquaries. No medieval English shrine of precious metal remains today, and very few reliquaries. The

rigorous ousting of Roman Catholic ritual in England in favour of the Protestant rite altered and lessened demand for church plate thereafter.

The earliest cups for the Eucharist resembled contemporary secular drinking cups, but in England, by the fourteenth century, the shapes of secular and church vessels began to diverge. Chalices were distinguished by two features, the knop and foot. At an early date and for ease of use the stem developed

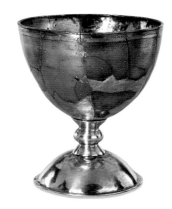

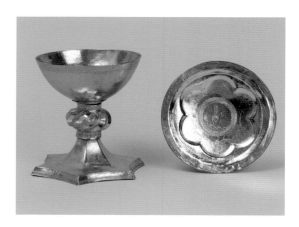

Top: Fig. 12 The Trewhiddle Chalice, silver, parcel-gilt, *c.* 868 (British Museum)

Above: Fig. 13 Chalice and paten, silver, parcel-gilt, *c.* 1360 (Hamstall Ridware, Staffs.)

a central knop. This became increasingly prominent and by about 1500 had become highly decorated. The foot evolved in distinctive ways too. From being large and circular in the thirteenth century it had developed a smaller hexagonal shape by about 1350 (fig. 13). This in turn gave way around 1500 to an elaborate sexfoil formula (fig. 14). Most surviving English medieval chalices are rather small and plainly decorated. Their size was to an extent determined by their function, since, from the twelfth century until the Reformation in the sixteenth, it was generally the practice that only the officiating priest received wine. Before about 1100, when the laity also received communion wine, chalices could be much larger and fitted with two handles, like the famous ninth-century Irish Ardagh and Derrynaflan chalices, made perhaps for substantial communities. By contrast however, the Trewhiddle Chalice of *c.* 868 (fig. 12) is very much smaller and was perhaps made for a small chapel.

The decoration of most surviving English medieval chalices is very limited. Commonly an engraving of the Crucifixion adorns the foot (fig. 16), while an image of the head of Christ or the Lamb of God decorates the paten (fig. 15). One of the finest surviving English chalices and patens was found in the grave of a twelfth-century Archbishop of Canterbury, Hubert Walter (d. 1205) (frontispiece), but even this is only slightly more richly decorated. By contrast, medieval inventories such as that of 1245 of the treasury of St Paul's Cathedral in London describe the many sumptuous chalices owned by the cathedral, made of gold or silver-gilt,

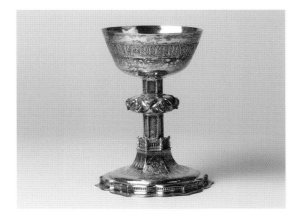

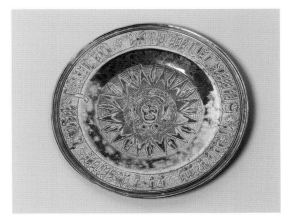

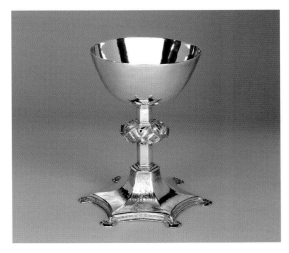

From top: Fig. 14 Chalice, silver-gilt, 1525 (Wylie, Dorset)

Fig. 15 Paten, silver-gilt, 1533, engraved with the vernicle (St Edmunds, Salisbury)

Fig. 16 Chalice, silver-gilt, 1489 (Leicester Domincan Priory)

often studded with pearls, sapphires and rubies. All these have been melted down. What remain with us today are mostly modest chalices from parish churches or the grave chalices, such as have been found in cathedrals and churches in York, Lincoln, Salisbury and Canterbury, which were buried with their owners. They reflect the practice, common until the end of the medieval period, of burying a priest with his emblems of office, a chalice and paten, and in the case of an abbot or bishop, also with his ring and crozier, such as a twelfth-century example from Durham Cathedral (fig. 23).

The cross is the distinctive emblem of Christianity. The sign of the cross first appears in early funerary inscriptions but was probably not made into a separate object before about 350 AD, when it was used in private prayer. Only from *c.* 1000 AD was a cross regularly placed on the altar during Mass; a more ancient custom was to place it beside the altar or to suspend one above it. Crosses were also carried in procession, in early centuries being hand-held and later replaced by larger and more visible crosses, attached to poles and raised up. Crosses were generally made of a precious material – silver, silver-gilt, gold or ivory – and decorated with gems. No large English medieval precious metal crosses have survived, but the form of the later ones is likely to have resembled the numerous surviving copper alloy examples of the late fifteenth or early sixteenth centuries (fig. 17), decorated with the symbols of the Evangelists and the figure of Christ. A small number of pectoral crosses survive, to be worn around the neck, made gold or silver, as from

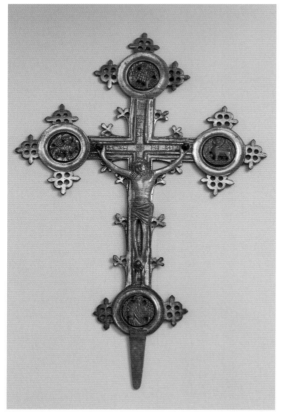

Top: Fig. 17 Processional cross, brass, *c.* 1500
(St Dominic's Priory, London)

Above: Fig. 18 The Wolsingham Cross, silver, early 16th century,
view from front and back (Durham Cathedral)

Durham Cathedral (fig. 18). Some of these were
made to contain relics.

The cult of relics was inspired by veneration for
the graves of early Christian martyrs in the third and
fourth centuries but it reached a climax in the
twelfth and thirteenth when Crusaders returning
from the Holy Land brought back relics supposed to
be of Christ, such as fragments of the true cross or
the crown of thorns, and the bones and clothing of
saints. Precious cases or reliquaries were created for
these, each as richly adorned as the owner could
afford. Relics believed to have miraculous powers
were often exhibited to the faithful in monstrances,
which had a central transparent receptacle of rock-
crystal. English inventories from the Middle Ages
describe many such pieces and it is a measure of the
scale of destruction at the Reformation that none of
these survive.

Going on pilgrimage to visit the shrines of
saints has been of great importance to Christians
since early times. Saints have been revered for their
sanctity and for particular powers attributed to
them. Shrines were usually in a site closely con-
nected with that saint, such as the place of his or her
martyrdom or burial, in a church or cathedral. By
praying at a saint's shrine, pilgrims hoped for cure
from sickness and for the remission of their sins.
Shrines usually contained all or part of the saint's
body, in a stone coffin, enclosed in a structure
entirely sheathed in gold, silver, enamels and pre-
cious stones. The cost of these shrines was so great
that work often continued on them for several
generations, as at St Alban's Abbey in the twelfth and

thirteenth centuries. Pilgrims might subsequently add their own gifts of jewellery or plate to a shrine. Many English medieval kings had favourite shrines: Edward I favoured that of Edward the Confessor in Westminster Abbey, Henry VI was so devoted to that of St Edmund at Bury St Edmunds (fig. 11), that he spent the Christmas season of 1430 there.

One of the most visited shrines in medieval Europe was that of St Thomas Becket, in Canterbury Cathedral. Becket was martyred in 1170 and created a saint just three years later. A pilgrimage to Becket's shrine was the occasion of Chaucer's *Canterbury Tales* and the most famous description of the shrine is Erasmus's account of his visit in 1516, when he described 'a coffin of wood covering a coffin of gold, which being drawn by the ropes and pullies, an invaluable treasure was discovered. Gold was the meanest thing to be seen there. All shone and glittered with the rarest and most precious jewels of an extraordinary bigness; some were larger than the egg of a goose. When this sight was shown, the prior, with a white wand, touched every jewel, one by one, telling the name, the value and the donor of it.' Eighteen years later, on the orders of Henry VIII, the shrine was destroyed, yielding gold and silver that, along with the contents of the Cathedral treasury, filled twenty-six cartloads. These were taken to the Mint in the Tower of London, and melted down, into new coins and new plate for the King.

Many of the few pieces of medieval church plate in existence today have survived only by being lost, hidden or buried and discovered centuries later. The Victoria and Albert Museum's fourteenth-century

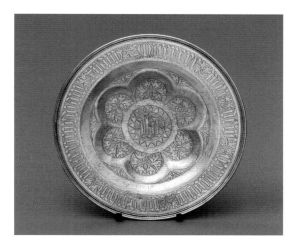

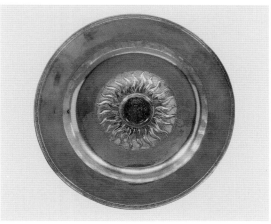

Top: Fig. 19 Paten, silver-gilt, late 15th century, engraved with the Sacred Monogram (Wroughton on the Green, Bucks.)

Above: Fig. 20 Bishop Fox's ablutions basin, silver-gilt and enamel, 1514, maker's mark orb and cross (Corpus Christi College, Oxford)

incense boat and censer from Ramsey Abbey, for example, were discovered in Whittlesey Mere in the 1850s by a man fishing for eels, and the outstanding Dolgellau Chalice and Paten (Royal Collection, on loan to the National Museum of Wales) were found on a hillside in Wales in 1890. We very rarely know anything about the original makers or owners of these pieces. It is thus exceptional to find a collection

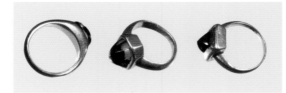

Fig. 21 Three rings, gold and sapphire, late 11th–mid 12th century, from the graves of Bishops Flambard, Rufus and Ste Barbe (Durham Cathedral)

of plate such as that at Corpus Christi College, Oxford, all owned or commissioned by the college founder, Bishop Richard Fox (d. 1528).

As Bishop of Winchester from 1501, Fox presided over the wealthiest bishopric in England, with an income which rivalled that of the King and the richest magnates, and with corresponding status and power. His extant plate reflects his secular and religious roles and is perhaps typical of the opulent way of life that a medieval bishop would enjoy. The pair of large silver-gilt basins for the washing of hands (fig. 20), either at mealtimes, or possibly as part of the ritual of the Mass, are each enamelled with Fox's arms as bishop of Winchester, and made in London by different but unknown makers, one in 1493–94, and the other in 1514–15.

Fox's large finger-ring is set with a facetted sapphire. Symbolic of purity, sapphires were often used for bishops' rings, as for example on those of the twelfth and thirteenth centuries found in bishops' graves in Durham and York. Medieval bishops and archbishops might own many rings, and were generally buried wearing one. The receiving of a ring was an essential feature of the consecration ceremony of medieval prelates. The seventh-century Synod

of Milan stipulated that these rings had to be of gold, set with an unengraved gemstone, but otherwise there are no special characteristics to enable them to be identified. In England, although it was the normal, but not invariable, practice for consecration rings to be returned to the royal treasury after death, some extant rings found in graves – such as the group of three from Durham (fig. 21) made of gold set with a sapphire – are likely to be consecration rings. At High Mass and for other major church ceremonies a bishop would wear his pontifical ring, usually over a glove on the fourth finger of the right hand. These were of exceptional size and often set with several gems, like those from the graves of Archbishops Hubert Walter of Canterbury (d. 1205) or Walter de Gray of York (d. 1255).

The plate particularly associated with Fox in his role as bishop is remarkable. His chalice and paten (fig. 22) are of gold, delicately enamelled, and bear the London marks for 1507–08. They are the earliest of all English hallmarked gold vessels to have survived. Most striking of all is his enormous

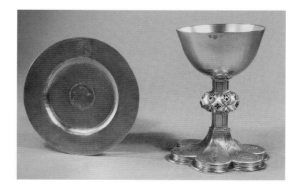

Fig. 22 Bishop Fox's chalice and paten, gold and enamel, 1507, maker's mark a fleur de lys (Corpus Christi College, Oxford)

and highly wrought crozier (fig. 2), the symbolic staff of office of a bishop, carried before him in procession on all ceremonial occasions. These were generally bequeathed to a successor in office, unless the bishop in question had founded a college, as did Wykeham, Waynflete and Fox, who all left their episcopal regalia to their colleges. At nearly six feet long, Fox's crozier is of silver-gilt, enamelled and decorated with finely modelled silver figures of the twelve Apostles set into arcades of Gothic niches. Microarchitecture in cast silver dominates the decoration, which otherwise includes enamelled roundels of saints around the knop, and roses and pelicans – Fox's badges – along the sides. The crook of the crozier encloses a dominant figure of St Peter, holding the keys of Heaven. This plausibly suggests that the crozier was made during Fox's time as Bishop of Winchester (1501–28), since the cathedral is dedicated to St Peter.

A final remarkable survival, which may possibly be linked with Archbishop William Warham of Canterbury (d. 1532) is a silver pax of *c.* 1500, from New College Oxford (fig. 9). It is the only known English precious metal pax, amongst a handful of otherwise copper alloy examples. All churches would have had one, symbols of peace and love, and used at Mass from about 1200 before Communion, being kissed by the priest and then by each of the congregation.

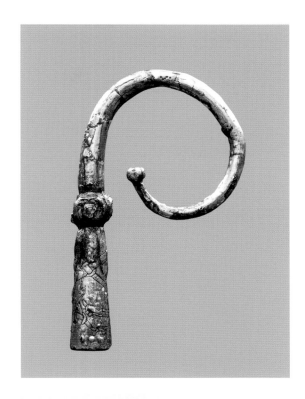

Above: Fig. 23 Crozier head, 11th–12th century, iron, silver and niello (Durham Cathedral)

Fig. 24 Pallium pins from Archbishop Walter's grave, silver-gilt, late 12th century (Canterbury Cathedral)

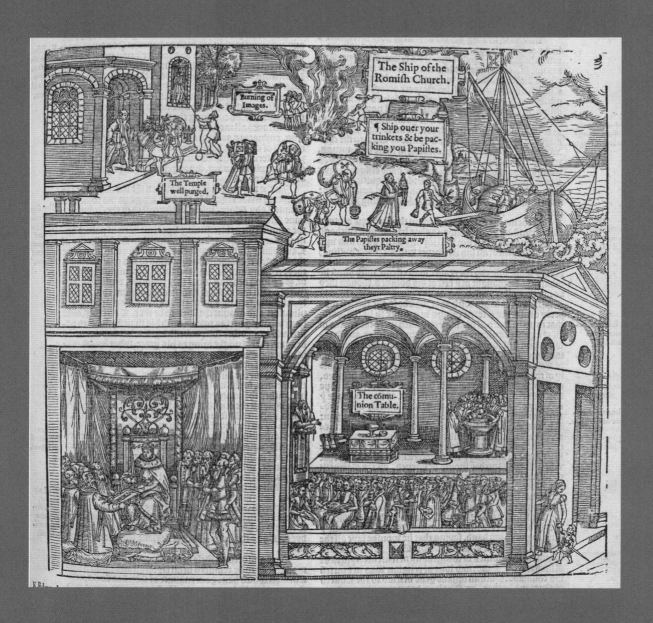

Fig. 25 Iconoclasm and the cleansing of the house of God (from *Foxe's Book of Martyrs*, 1583), woodcut (Victoria and Albert Museum)

The Tudor Reformations

Sophie Lee and Alec Ryrie

In a volume on the treasures of the English Church, a chapter on the Reformation era is an inevitable but unwelcome guest. For, during the sixteenth century, the English Church systematically destroyed most of the objects which were once considered its treasures. Only a few fragments of the medieval past survive. Indeed, the destruction was so complete that it even disguised itself. The image-smashing of the Civil War is better known, for that was the work of zealous soldiers and individuals, piecemeal and opportunistic, who left their work half-done. The iconoclasm of Tudor England was more bureaucratic, more drawn-out and far more thorough. It was not a storm of violence, but a steadily rising flood. It is with that relentless destruction that we must begin.

The deliberate destruction of beautiful and ornate objects is, to modern eyes, mere barbarism. But we cannot understand the sixteenth century unless we understand why some of the most brilliant and cultured people of the age were willing – indeed, eager – to do such things.

There was a simple and ignoble reason for much of the great destruction – money. During the early 1530s Henry VIII's matrimonial spat with the Pope escalated into a wider jurisdictional quarrel, leading to the King's declaration, in 1534, that he was Supreme Head on earth of the English Church. This headship, as Henry conceived it, made him master of the Church's practices, property and even its doctrines. The fox had appointed himself lord of the chicken-coop. That was not how it appeared at first and Henry was no doubt sincere in his intention to govern the Church benevolently. But his secession from Rome raised fears of foreign invasion, fears which induced the King to spend even more on military matters than he was already inclined to. And the process of handling the Church's wealth was worm-eaten with temptation, both for the King and for his officials. The most notorious episode is known to history, coyly, as 'the dissolution of the monasteries' – the biggest single seizure of property in English history, conducted in the name of reforming corruption and of benefitting the commonwealth, but ending with by far the greatest part of the religious houses' wealth in the hands of the crown and its servants.

During this process, most of the holiest objects and places in England were desecrated. England's greatest shrine, that of Thomas Becket at Canterbury, was utterly annihilated, the precious metals melted down and the saint's relics pulverized (fig. 26). Henry VIII had a particular dislike for this saint, who represented defiance of royal authority, but Becket was not the only victim. The relic of the Holy Blood at Hailes Abbey in Gloucestershire was brought to London to be exposed as a fake in 1538 (it was claimed, variously, to be duck's blood or to be honey coloured with saffron), and subsequently destroyed. Likewise, at St Osyth's Abbey in Essex, the silver-mounted skull of Saint Osyth and other relics were amongst a wealth of jewels and plate seized, the plate alone totalling £185 17s 8d. However, most parish churches suffered relatively little damage during Henry VIII's reign, nor did their worshipping life change dramatically. Only where shrines, relics or images had attracted particular veneration did the royal commissioners hunt them out, and then they did so piecemeal.

Yet there was more, much more, to this than plunder. Even in Henry VIII's reign, the urge to destroy sacred objects was a matter of conscience, turning on the most controversial of the Ten Commandments. As the first officially approved translation of the Bible into English, the so-called 'Great Bible' of 1539, put it, 'Thou shalt make thee no grauen ymage of any maner of likenesse that is in heauen aboue, and that is in erth benethe Thou shalt neither bowe thy selfe vnto them, nor serue them, for I the Lorde thy God, am a gelouse God.' This ancient prohibition on images, which had become so powerful for Jewish and Islamic consciences, had been all but abandoned in the Christian West. Christ's incarnation, in which God actually had taken on physical form, seemed to make the commandment redundant. Indeed, it was no longer treated as a separate commandment, being treated as a subclause of the First Commandment (the tenth was split in two to make up the traditional number). The 'Reformed' Protestants of Switzerland and southern Germany restored the commandment to its ancient place, and the Bibles of the English Reformation followed. Nor is the Bible's attack on idolatry by any means restricted to this one commandment. The Old Testament rings with it. In particular, the biblical histories of ancient Israel measure the quality of kings by a single yardstick – whether or not they destroyed idols. Henry VIII, who took himself so seriously as a godly king, read and learned.

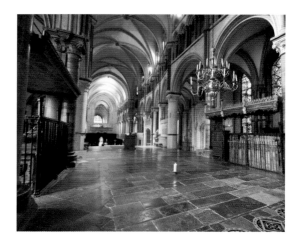

Fig. 26 The site of the shrine of St Thomas Becket in Canterbury Cathedral

The process of destruction changed gear during the short reign of Henry's successor Edward VI (1547–53). Royal injunctions published six months after the boy king's accession demanded that clergy were to 'take awaie, vtterly extincte, and destroye, all shrines, coueryng of shrines, all tables, candelstickes, tryndulles or rolles of waxe, pictures, paintynges, and all other monumentes of fained miracles, pilgremages, Idolatry and supersticion: so that there remain no memory of the same, in walles, glasses, windowes, or els where, within their churches or houses. And thei shall exhorte all their parishoners, to doo the like within their seuerall houses.' This list – which was enforced with gusto – might seem comprehensive enough, but the war on monuments of superstition only accelerated during the remainder of the reign. Altars, the great consecrated stones at which the sacrifice of the Mass was celebrated, were torn out to be replaced with wooden tables. Even stained-glass windows were targeted. One did not smash windows lightly, since they were expensive to replace and church buildings were scarcely warm or dry to begin with. Yet they could be, and were, whitewashed easily enough, the loss of a little light a small price to pay for the blotting out of blasphemies.

For it was as blasphemies that they were seen. In 1551 or 1552, the firebreathing Protestant agitator John Bale visited a church in rural Hampshire where the curate had taken all the prohibited images and objects and stowed them out of sight, in the belfry and steeple. Bale was furious at what he called 'ye craftie conueyance of certen images in hope

of a change', and pointed out that the law required 'that all ymages shulde, not only be remoued out of the churches … but also that they shulde be defaced, mangled, and vtterly destroyed for theyr abhomynacyons'. For the Protestant vanguard such sacred objects were not merely idols which might tempt good Christians into placing their faith in them: they were offences before God which had to be destroyed. It is this conviction which explains the unforgiving thoroughness of the destruction.

Yet, even during the Edwardian high tide of iconoclasm, financial considerations were overriding. In 1547–48 another great set of ecclesiastical foundations, the chantries and collegiate churches, were dissolved and their property taken, an act of asset-stripping so naked that even Archbishop Thomas Cranmer, the regime's Protestant standard-bearer, at one stage voted against it in Parliament. The regime's ravenous appetite for Church property became even clearer when the campaign stepped up again in 1552. Surviving inventories of the 'goods, plate, jewels, bells and ornaments' belonging to cathedrals and parish churches in that year give an alarming picture of how much was lost. Visiting commissioners were instructed to list all their surviving furnishings and to account for discrepancies from inventories made three years earlier – to uncover cases of theft, unauthorized sales or concealment of goods. All was to be done soberly and discreetly, perhaps noting a concern for any ingrained affections that must still have existed for the reassuring trappings of the old faith. Plate and jewels were to be sent to the Jewel House, the royal

treasury in the Tower of London, leaving a meagre one or two chalices for each cathedral, collegiate church or larger parish, and a single chalice for each small parish or chapel – though these had to be practical and of good enough quality for administering Holy Communion.

Shrewd parishes had foreseen the inevitable seizure of their more valuable goods and sold plate to local goldsmiths or businessmen to pay for 'allowable' repairs to their properties, or even – in a few rare circumstances – to commission new Protestant plate. In March 1551 the churchwardens of St Michael, Cornhill, in the City of London, had a goldsmith make a 'comnyon cup waying xxj oz & qr' for them; he made it from a gilt chalice weighing 20 ¾ oz. which they provided, along with two shillings and fourpence for the remaining metal and £2 for his fee. From their visit to the parish of St Nicholas in Guildford in 1552, the commissioners recorded a single 'chalice of silver and gilte' but the rest of the plate which had been there in 1549 (a silver-gilt cross, two covered chalices, a pyx and a pair of censers) had been 'sold for the reparacions of the churche whereof they make none accompte because the reparacions a[r]e not yett donne'. Since the looting was going to happen anyway, the good people of Guildford made sure that they at least kept some of the proceeds.

The destruction came to a sudden halt with the death of young King Edward in the summer of 1553 and the accession of his Catholic half-sister Mary. During her even shorter reign, her bishops made a colossal effort to rebuild and replace what had been lost. Given that they had scarcely five years, and were dogged by economic crisis, epidemic disease and crippling political uncertainty, the programme of restoration achieved an impressive amount. It helped that enough plate had survived to provide most parishes with the basics, and to spare them the considerable and risky expense of commissioning new items. But it would have taken generations fully to undo the damage of the previous twenty years, and time was not on Mary's side. When she died in 1558, Henry VIII's last surviving child, Elizabeth, became queen, and restored a variant of Edward VI's Church. The iconoclastic tide began to rise again, sweeping away what had been restored under Mary. Slowly, deliberately, obediently and in an orderly fashion, parishes across the country destroyed their valuables and blotted out their history. We may assume that many people had misgivings about this, but it was characteristic of Tudor England that, however reluctantly, almost everyone obeyed. The historian Eamon Duffy has called this calm obliteration a 'sacrament of forgetfulness': it ensured that there could be no going back, and made England's past a foreign country.

Modern eyes might deplore this as fanaticism, but there is an irony here. Whatever else one might think of Protestant iconoclasm, it attached real spiritual importance to images and other church furnishings. In this, at least, those who made and treasured those objects had more in common with image-smashers than they do with those of us who admire the objects in museums or exhibitions because they are pretty.

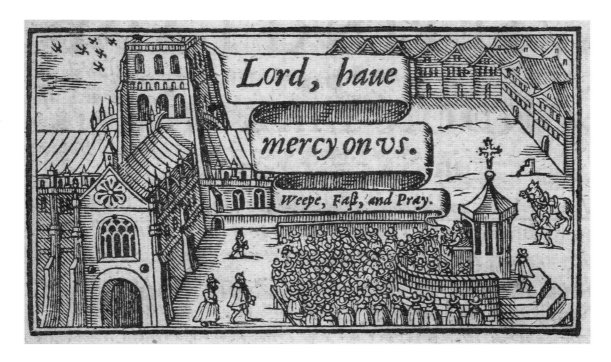

Fig. 27. Open-air preaching at St Paul's Cross (from Thomas Brewer, *The weeping Lady: or London like Ninivie in sack cloth*, 1629), woodcut (British Library)

Alongside the main narrative of destruction, however, there are other stories to be told about church furnishings in the sixteenth century. A few new, distinctively post-Reformation types of object were created to be put in their place. The most important of these to the Protestant reformers was the pulpit. Protestantism was unashamedly a religion of the Word. The Catholic Bishop of Winchester, Stephen Gardiner, wrote with distaste that Protestants only came to church 'to heare one talke and rayle after theyr fansy in a pulpet, which they calle a sermon' (fig. 27). Indeed, the royal injunctions of 1547 demanded that every church install 'a comely and honest pulpitte … for the preachyn of Gods woorde'. Preaching was not a Protestant invention, but what had once been an occasional sweetmeat was now intended to become churchgoers' staple diet. The pulpits from which the new message was thundered forth consequently became more elaborate. Few Tudor pulpits survive – they were wooden structures in continual use – but churchwardens' accounts testify to their construction and embellishment, as do a few contemporary depictions. A canopy or tester above was a common addition, which not only made the pulpit more imposing but also – for this world with neither amplification nor artificial hearing aids – served as a sounding-board. An hour-glass might also be fixed to a pulpit (Protestant sermons routinely lasted over an hour, and often extended to two), perhaps alongside a candlestick to help the preacher read his notes. Whereas pre-Reformation pulpits had often been

Fig. 28 Detail from a silver alms dish from Trinity College, Edinburgh, showing the Lord's Table; Thomas Kirkwood, Edinburgh, 1633 (National Museum of Scotland)

decorated with images of the saints or biblical scenes, the more austere post-Reformation style was for improving biblical quotations, the royal arms or other heraldry, or that most politic and heartfelt of sentiments, 'God save the Queen'.

Besides the Word rightly preached good Protestants also held that a mark of a true Church was the sacraments rightly celebrated. The holocaust of church plate could not, therefore, be complete: some remnants were needed even for the simplified Protestant service of holy communion. In particular, there was a newly prominent role for the communion cup. In the medieval Church, communion as such had been an occasional event: usually, the bread and wine consecrated at Mass were consumed only by the priest who presided at the altar. When the medieval laity did receive communion (normally only at Easter), they received it in 'one kind' – only the consecrated bread, the wine being reserved for the celebrant. This ancient custom was challenged by Protestant reformers who saw it as a symbol of

the pride and exclusivity of the clergy. Communion 'in both kinds' became a rallying-cry for Protestants across Europe. The issue never raised the same passions in England as it had elsewhere, but it was still a Protestant commonplace that 'all thos are antechristes that do deney ley men the Sacramente of the aulter sub utraque specie [in both kinds]'.

When the reformers finally triumphed over 'Antichrist' in this matter, under Edward VI, the new requirements of the Prayer Book had to be met on the communion table. Now that whole congregations were drinking from the cup, flagons were introduced to replenish it during the service and to store the reserved wine (fig. 28). In such straitened times, domestic pewter flagons were initially acceptable, but by the end of the century silver vessels were considered more appropriate. Some were in church use by the 1570s but one of the earliest documents referring to them is Archbishop Whitgift's 1597 articles for the deanery of Shoreham, which

Fig. 29 Alms dish, silver-gilt, 1548, maker's mark W (St George's Chapel, Windsor)

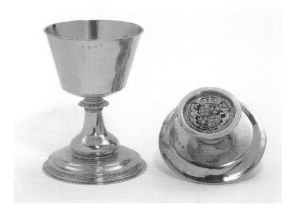

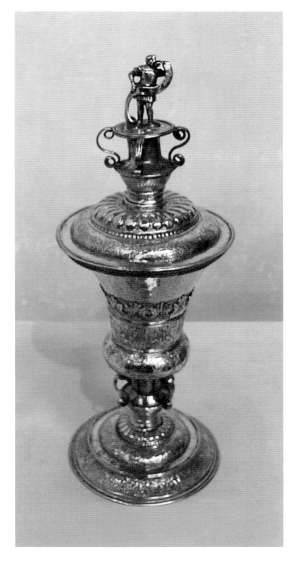

requested 'two comely pots of silver or pewter to fetch wine to serve the Lord's table, reserved and kept clean to that use only, being no tavern pots'. Town parishes with large congregations sometimes preferred to buy a second cup instead of a flagon, to reduce the costs. Patens for the distribution of bread survived the Reformation by alteration into a new form which, while retaining the medieval dual purpose of dish and cover, had a central knob which acted as a foot or handle. This new form of paten emerged during Edward's reign and was in general use by the mid-1560s (figs. 30, 39 and 43–45).

A Protestant aesthetic for church silver took time to emerge. With the authorization of communion in both kinds in 1548, a few wealthy congregations commissioned new communion cups in designs closer to secular wine cups than to the old Gothic chalices, or bought secular cups for the purpose (fig. 31); but religious enthusiasm rather than state compulsion seems to have motivated them. The majority of parishes across England still drank from their one remaining chalice. A more concerted effort to create a new look for the new faith emerged under Elizabeth, possibly inspired by the practice of Swiss reformers (see fig. 36) – who, unlike the

Above:
Fig. 30 Communion cup and cover, silver-gilt and enamel, with the arms of Edward VI on the cover, 1549, maker's mark probably a tower
(St Mary Aldermary, London)

Fig. 31 Cup and cover, silver-gilt, 1543, maker's mark a cross
(St Peter Mancroft, Norwich)

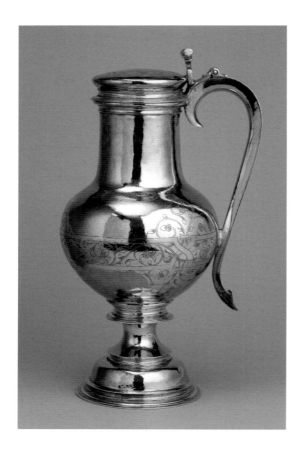

Fig. 32 Flagon (one of a pair), silver, parcel-gilt, 1592, maker's mark WH (Rendcomb, Gloucs.)

German Lutherans, found their consciences troubled by the continued use of popish vessels. The English Church now deemed it necessary to bury the memories of 'superstitious' practices by obliterating and replacing the objects which might stir them up. The earliest surviving document relating to the compulsory conversion of old 'massing' chalices is Bishop Guest's injunction of 1565 for the diocese of Rochester 'that the chalice of every church be altered into a decent communion cup therewith to minister the Holy Communion, taking away no more thereof but only so much as shall pay for the altering of the same into a cup'. But it was almost certainly not the first and it is clear that, soon after becoming Archbishop of Canterbury in 1559, Matthew Parker initiated a campaign of compulsory refashioning, starting with the dioceses of London and Canterbury and spreading out across the rest of England through the following two decades (see Chapter 4).

The Edwardian goldsmiths had enjoyed a relative freedom of design, encouraged by a generosity of funds released by churches whose goods had not yet been seized. By contrast, a new economy of style prevailed after the 1559 Church settlement, since parishes were explicitly not required to supplement the metal melted down from their old chalices. (There were of course exceptions: some churchwardens chose not to melt down their old chalices, either retaining them for posterity or selling them at a later date, but rather met the expense of new cups by other means or accepted gifts of secular cups.) Contrary to the popular belief that Elizabethan cups were much larger than their medieval counterparts, some new cups were very small indeed. It would be over-simplifying matters to state that the Elizabethan cups all conformed rigidly to a pre-ordained design, but they were sufficiently similar in shape, decoration and simplicity, whether made in London, Exeter or Chester, to become emblematic of the new order (see also figs. 37, 39–43 and 160).

Parker's campaign resulted in a flood of commissions that provided a welcome boost for a trade that had been stagnant for nearly three decades. Henry VIII's plunder had made church plate seem a

rash investment and it appears that virtually nothing
was made between 1537 and 1548. The first Protestant
vessels emerged in London under Edward (fig. 30),
but these pieces, though generous in size and weight,
were rare (only eighteen cups survive). Under Mary,
a return to the Mass had also failed to bring new
custom. Surviving cups from the Elizabethan
period, on the other hand, number over two thou-
sand, evidence of a greatly reinvigorated trade.

One other Protestant preoccupation gave rise to
a distinctively new object, the alms dish (fig. 29).
From the earliest days of the Reformation Protes-
tants trumpeted their concern for the poor. The
medieval Church had regarded giving alms to the
poor as a high work of mercy, but almsgiving was
only one of many ways in which medieval Catholics
could spend their wealth piously: the poor jostled
with saints whose shrines could be adorned, with
churches and clergy whose furnishings and vest-
ments could be beautified, and above all with the
suffering souls of the dead in Purgatory, who so des-
perately needed Masses said for them and good
works performed on their behalf. To Protestants, all
of these competing needs were mere scams practised
by grasping and unscrupulous priests. The ultimate
victims of these frauds were the poor, who had been
deprived of the charity that was rightfully theirs.

So Protestants positioned themselves as the
poor man's friends. Nor was this mere positioning:
the responsibility of the rich to care for the poor was
a constant theme of their preaching. This was espe-
cially true under Edward VI, whose reign was a time
of idealism but also of high taxes, runaway inflation

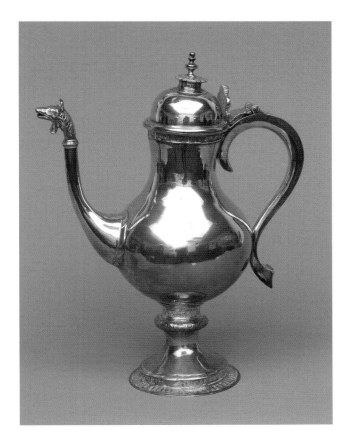

Fig. 33 Flagon, silver, 1610, maker's mark indistinct (St Michael, Oxford)
Inscribed 'For the use of the Lord's table in St Martin's Church Oxon.
The guift of Mr. Daniel Hough, 1645'

and consequent social dislocation. The alms dish is
as characteristic of the Reformation era as the com-
munion cup, for it represents not only the genuine
Protestant concern for the poor but the successful
efforts made to keep that concern within socially
acceptable bounds. The rhetoric of 'commonwealth'
could sound carnivalesque or even revolutionary.
It stirred hopes and fears which helped to provoke
disturbances across much of southern and eastern
England in the summer of 1549, one of which (Kett's
Rebellion in Norfolk) ended in a good deal of
bloodshed. This was not what respectable Protestant

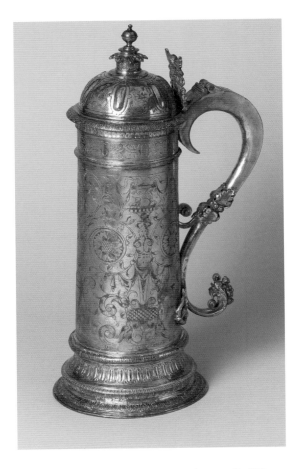

Fig. 34 Flagon, silver-gilt, 1607, maker's mark TB (Westacre, Norfolk)

The alms dish can, indeed, serve as a symbol of what the 'treasures' of the post-Reformation Church of England really were. This was a Church which claimed, in a pious tradition going back to the legend of St Lawrence, that its true treasures were the poor; and which chose to expend its wealth more on the support of the poor than on the maintenance of its own physical splendour. That was a theological decision, and also – in a period of increasingly severe economic dislocation – a practical one. Yet that severe idealism was a cloak (a threadbare cloak) for the fact that the Church's physical estate was now far more directly under state control than ever before. From the regime's point of view, indeed, Reformed Protestants were very convenient subjects. With their suspicion that ornate and expensive objects were blasphemous idols, and their preference for spending their wealth on relieving the Queen's poor subjects instead, they effectively shouldered part of the burden of state. The physical impoverishment of their Church was a price which both sides were willing to pay.

preachers had meant at all. Their meaning is better conveyed by an alms dish at St George's Chapel, Windsor, made the year before (fig. 29). The wealthy should give to the poor, not the poor take from the rich. They should give in an orderly fashion, in church, and under the sovereignty of the King, whose symbolic presence is marked by the Tudor rose. Half a century later the Elizabethan Poor Law of 1601 would give legislative expression to these aspirations, in a comprehensive, paternalistic and tolerably generous system of poor-relief that was to endure until the 1830s.

Facing page
Top left:
Fig. 35 Communion cup, silver-gilt, 1553, marker's mark RM (Great Houghton, Northants.)

Top right:
Fig. 36 Communion cup and cover, silver, parcel-gilt, *c.* 1560, unmarked, probably Switzerland (Kingston Buci, West Sussex) Perhaps of secular origin, the cover has been altered so that it may serve as a paten.

Lower left:
Fig. 37 Communion cup and cover, silver-gilt, 1569, maker's mark indistinct (Stoke Hammond, Bucks.)

Lower right:
Fig. 38 Communion cup, silver, 1562 (St Michael, Oxford)

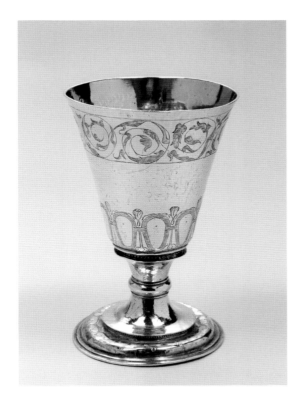

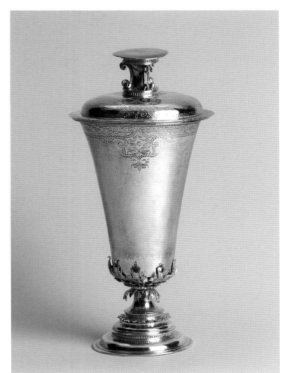

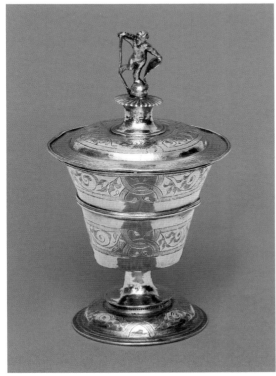

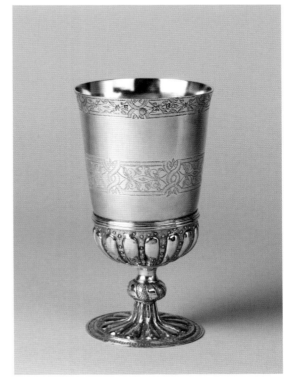

Fig. 39 Communion cup and cover, silver-gilt, 1558, maker's mark indistinct (St Michael le Belfry, York)

'Decent Communion Cups' A National Campaign

Timothy Kent

The proliferation of silver communion cups of essentially standard design across the whole of England was an Elizabethan phenomenon. The spoliation of church plate under Henry VIII was a process that devastated religious houses, chantry chapels and shrines but left parish churches largely unaffected. Even under Edward VI, whose commissioners took stock of parochial plate in each county and confiscated much of it for the king's use, the plate required for the administration of holy communion – chalices and patens – was generally left intact. As a result, by the time Elizabeth I came to the throne in 1558 most parishes outside London were still using their old chalices.

Elizabeth's restoration of the sacramental cup to the laity gave a powerful stimulus to a new policy to convert all chalices into 'decent communion cups' that had a greater resemblance to secular wares and that broke away from the 'superstitious' associations of the old vessels. At the head of this massive administrative undertaking was Matthew Parker (1504–1575), who was consecrated Archbishop of Canterbury in December 1559 and who (although no explicit document has been found) is presumed to have issued instructions that led to the conversion on a systematic and phased basis, diocese by diocese. (Parker was, incidentally, evidently very interested in silver, judging by his generous benefactions to his Cambridge college, Corpus Christi, of which he had been Master).

Some parishes had been quick off the mark and one of the earliest of the new reign was the exceptionally fine London-made cup and paten-cover (fig. 39) of 1558 belonging to the York parish of St Michael-le-Belfry, possibly acquired for use during Holy Week of 1559. This beautiful cup stands some 17 cm high and weighs 12 ozs 18 dwts, suggesting a wealthy parish. Most regional communion cups date from later and the major refashioning took place between 1562 (when a Convocation was held in London) and 1577, which is a common date in west Cornwall. It may be no coincidence that 1562 is the most commonly found date in the dioceses of Canterbury and London, where parishes were closer to the centres of political and religious control.

The normal procedure was for the parochial chalice to be traded in to a goldsmith, who would refashion it appropriately and retain a small quantity of metal (worth about 5s 6d per ounce) as payment. A prosperous parish would have money to add and in this context the churchwardens' accounts of Braunton in North Devon (1576) may be quoted: 'Item, for a Comunyon Cupp of xxviii ownces lacking half a quarter at v s vi d the ounce, vii l [pounds] xiii s iiii d whereof we received for a challis of xv ownces and a half at v s vi d the ounce, iiii l. Item, for making a Bagg for the Comunyon Cupp, iiii d'. A parish like Braunton, however, was exceptional. Comprising 10,000 acres of rich agricultural land with half a dozen manors, it could afford to add another £3 for a much larger new cup, whereas small parishes on the fringes of Exmoor got back a cup no larger than the old chalice and scarcely bigger than a wine glass.

Whether made in London or by local goldsmiths, the communion cups supplied to parishes across the country during this period show a broad conformity to the general pattern established in London (see Chapter 3), although provincial makers often developed distinctive regional variations of their own.

Although these are lacking at a national level, there is some evidence of the issue of specific instructions for conversion locally. On 19 November 1572, for example, the Chapter of Wells Cathedral ordained that 'the [cathedral] plate that beforetime were used to superstition shall be defaced, and of the great Challaice shall be made a fayer Communion Cuppe with as much convenient speede as may be before the Feast of Easter, and of the lesser challaice another by the time before limited'.

It seems that in some dioceses, such as Bath and Wells where 1572 and 1573 are the commonest dates, some kind of central facility was organized, as many cups of those dates are London-made and bear a maker's mark IP. Gerald Taylor has suggested that this could be that of John Pinfold or John Pinkard, both of the London Goldsmiths' Company, the latter having been apprenticed to Robert Danbe, a known maker of communion cups.

In other parts of the country, notably Wessex, East Anglia and the Midlands, much of the work went to local goldsmiths: awareness of this may account for the searches undertaken by the Goldsmiths' Company to determine whether local manufacturers were working to the correct sterling standard. The company's officers visited East Anglia in 1568 and the West Country in 1571; in 1573 they made a further tour of midland and northern counties.

Taking the West Country first, in the sixteenth century, when Devon and Cornwall were entirely in the diocese of Exeter, much work went to the leading Exeter goldsmith John Jones (working 1555–83). He made as many as 150 cups for parishes in Devon and Cornwall, mostly dated 1575 and 1576 and sometimes struck with unofficial date-letters A and B. Jones's fine cup for St Petrock's church in Exeter (fig. 40) is among the first and is recorded in the churchwardens' accounts for 1572 with the entry 'payed to John Jones goldsmith for changing the challis into a communion cup, xxxv s 6 d'.

Jones did not have a monopoly of this business, however. A number of communion cups in the diocese are by other local goldsmiths such as John North, Richard Osborn, and Steven More of Totnes, some of which share the distinctive 'Exeter lip' found on the St Petrock's Cup. Another major figure in the West Country goldsmithing community was the talented Barnstaple goldsmith Thomas Matthew (working there 1563–1611), who produced excellent work such as the Braunton cup, already mentioned.

In mid-Wessex, Salisbury was an important centre for making new cups during the 1570s, and the Gillingham Cup, dated 1574 (fig. 45), is one of the best examples as it shows two unmistakable Salisbury features, namely a vase-shaped knop surmounting a band of ropework and a simple band of interlaced decoration. Most Salisbury cups are undated, but usually carry the presumed town-mark or workshop mark of a pelleted circle. Not far away, two other workshops were active in the field, those of Richard Orenge at Sherborne and Lawrence Stratford at Dorchester. Orenge's cups, to be found in various parishes on the Dorset/Somerset border, bear his rebus mark of an orange, while Stratford's LS monogram mark is unequivocal. The River Stour constitutes the dividing line between Salisbury and Dorchester cups. Other makers of cups in the Wessex area include Humfrey Clovell of Bristol (working 1568–1626), Albert Williams of Gloucester, and Henry Arnold of Taunton.

The other prolific area of chalice-conversion in the southern half of the country is East Anglia, in particular Norwich, which in the sixteenth century

Fig. 40 Communion cup and cover, silver, John Jones, Exeter, 1572 (St Petrock's, Exeter)

was the second largest city in England and to which a total of some 570 pieces of church plate has been ascribed.

In the diocese of Norwich, the most active year for chalice conversion was 1567, following Rochester, where most cups date from 1565. Much of the Norwich silver of this period is attributable to three prominent goldsmiths of that city, Peter Peterson, William Rogers and William Cobbold. Peterson was

Fig. 41 Communion cup and cover, silver-gilt, Peter Peterson,
Norwich, 1569 (St Peter Mancroft, Norwich)

Edmunds, and the Waveney Valley. Marks on cups
of King's Lynn provenance have been ascribed to
Thomas Cooke, working there from 1578/9, while at
Bury St Edmunds a group of cups from the relevant
period bearing a fleur de lys mark may have come
from the workshop of Erasmus Cooke. In the
Waveney Valley area, the Chesten family were active
in Beccles and may well be responsible for a group
of cups. Goldsmiths, in particular the Gilbert family,
produced cups in the Ipswich and Colchester areas.

Moving up to the Midlands, the goldsmiths of
Coventry, Nottingham and Lincoln were mostly
kept busy converting old chalices. Many cups from

responsible for one of the finest and most impressive
Norwich communion cups, the 1568 cup belonging
St Peter Mancroft in Norwich (fig. 41). But a more
prolific maker was William Cobbold, whose orb and
cross mark is found on 116 pieces of surviving
church plate in Norfolk and Suffolk. A significant
number of goldsmiths were also working elsewhere
in East Anglia: Thomas Buttell, another major
Norwich goldsmith, moved to Cambridge and pro-
vided numerous parishes in Ely and Peterborough
dioceses with communion cups. In addition there
were busy local makers in Kings Lynn, Bury St

Fig. 42 Communion cup and cover, silver, John Morley, Lincoln, 1569
(St Nicholas, Snitterby)

this area have distinctive stem knops in the form of circular fluted discs and bands of 'hit-and-miss' decoration. S.A. Jeavons, in his study of Midlands goldsmiths, produced detailed maps of the location of cups attributable to three unidentified Coventry makers who used a rose mark, a cross, and initials IF, and together produced more than 100 cups. At Lichfield the partnership of John Gladwyn and John Utting produced a local group, while at Nottingham Nicholas Goston (or Gorston) and at Lincoln John Morley (fig. 42) were also engaged in similar activity. Typical engraved decoration for this region consists of arabesques, simple interlacing, or 'hit-and-miss' motifs.

In the province of York a similar pattern emerges. A large proportion of the cups in Yorkshire are marked for 1570 or 1571, hallmarked in London or York, a fact that is attributable to the reforming zeal of Archbishop Grindal, who held the Primacy from 1570 to 1575. On taking office he required his clergy 'to minister the Holy Communion in no chalice nor any profane cup or glasse, but in a Communion Cup of Silver'. Goldsmiths in York or Newcastle, and Edward Dalton of Carlisle, shared much of the work arising from this instruction, their products being mainly of standard type. At York, Robert Beckwith (working 1546–85), Robert Gylmyn (working 1550–86) and William Rawnson (working 1562–93) were prominently involved in production, while Valentine Baker of Newcastle is recorded as the maker of a cup dated 1583.

The south-western part of the province was centred on Chester, a goldsmithing centre whose

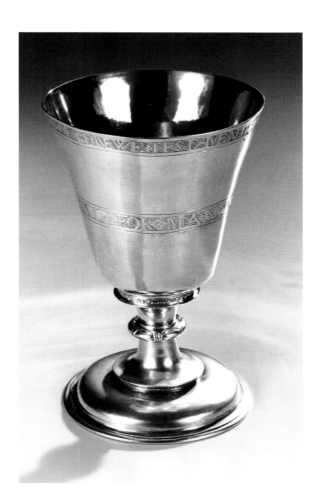

Fig. 43 Communion cup, silver, William Mutton, Chester, 1570 (Holy Trinity, Chester)

catchment area spread across into North Wales. This became an important source of business in 1573 when the dioceses of Bangor and St Asaph turned to the conversion of their chalices. The evidence suggests that in the Chester area much of the chalice remaking business went to John and Joseph Lingley and most notably to William Mutton (d. 1583/84). This goldsmith's name appears twice in the churchwardens' accounts of Holy Trinity, Chester, for 1570, the first entry recording the sale of the old chalices

and the second, some months later, the purchase of the new cup (fig. 43): 'Sould Wm Mutton gouldsmith 24 Aprell 2 Challises with 2 Kovers waying 33 ozs 3 quart: 4s 8 d an ounce, £7-17-6', followed by a payment of £6-18-10 for 'a Communion cupp and plate for breade'.

Fig. 44 Communion cup, silver, *c.* 1568, Chichester (unmarked)
(West Ichenor, Sussex)

Mutton's mark, a rebus of a sheep's head, appears on a number of communion cups in the adjoining Welsh Counties. His cups are of standard form: some have a band of 'hit-and-miss' decoration below the usual arabesque band.

The conversion process in this region, however, was rather more protracted than elsewhere, reflecting to an extent the attitudes of the bishops. William Downham, appointed Bishop of Chester in 1571, was an easy-going man who did little to deal with recusancy in the diocese. In 1577 he was succeeded by William Chadderton who took a firmer line: his visitation of 1581 included the question whether each parish possessed 'a faire and comely Communion Cuppe of sylver and a cover of sylver for the same.'

It remains to record an important group of cups in West Wales, dated between 1573 and 1587, evidently produced by one maker who appears to have been based in Carmarthen and who used an unusual mark of four circles connected in a line, 'oooo'. Oman recorded 77 of these cups, spread over West Wales, some of which have an arabesque band under the rim, and a further band below it carrying the parish name and date. This goldsmith is as yet unidentified but circumstantial evidence suggests a possible candidate: on 28 July 1571 Griffith Jenkyn, son of Griffith Jenkyn of Carmarthen, Tucker, was apprenticed to Edward Evennet, goldsmith of Bristol, and Katherine his wife. He did not become a Burgess at Bristol, so possibly the Bishop of St David's, whose palace was at Carmarthen, lured Jenkyn home to make communion cups, or there may be some other Bristol connection.

Despite these general trends within dioceses as a whole, there is an impression that pockets of conservatism or even recusancy in some areas led to churchwardens dragging their feet and only complying under pressure at a slightly later date than the majority. This would account for the interesting group of cups around Chichester, all unmarked and dating, in my opinion, from around 1580 rather than the main diocesan year of 1568. Recusancy was strong in West Sussex, where the influence of Anthony Browne, 1st Viscount Montague of Cowdray Park, was a powerful factor. The little cup of St Nicholas's, West Itchenor (fig. 44), is a good example of this group, with its distinctive engraving and unusual foot.

It is apparent that this reluctance affected the Wylye Valley in Wiltshire, too, where a number of parishes retained pre-Reformation items, and indeed Wylye itself succeeded in keeping its chalice of 1525, which remains in fine condition (fig. 14). At Morebath in North-East Devon the parish was obliged to sell their principal chalice in 1571 but the vicar, Christopher Trychay, who had been in office since 1520, continued to use a smaller chalice down to the end of his life in 1574. The Morebath communion cup, stolen between the Wars, is recorded as bearing the late date of 1593, which emphasizes the position. The Morebath record also makes it plain that crown commissioners, in addition to episcopal officers, could also pursue backsliders. But on the whole we may conclude that by 1580 the process was virtually complete.

Fig. 45 Communion cup and cover, silver, dated 1574, Salisbury (unmarked) (Gillingham, Dorset)

Fig. 46 Tankard, silver-gilt, 1676, maker's mark IH (Wing, Leighton Buzzard)
Inscribed 'The gift of Sir William Stanhope to ye Church of Wing'

From the Buffet to the Altar
Secular Plate in Anglican Churches

Philippa Glanville

Today, to find a Jacobean steeple cup, a late Stuart embossed tankard, a pot-bellied flagon, a seal-top spoon, a sweetmeat dish or a wine taster in an Anglican church seems odd. In the twenty-first century such supposedly domestic objects are considered anomalies. Driven by the desire to present a coherent narrative, museum curators have largely excluded them from their displays of church plate.

But this is to ignore past realities: the 'comely plate' and 'pure metal' appropriate for communion, baptism and collecting alms was easily adopted from domestic plate cupboards. Large plates for bread, knives to cut it, strainers for wine, ewers and basins for washing, jugs for beer and cider and candlesticks all formed part of domestic gentry silver. On special occasions lending secular objects for liturgical use was also acceptable: Chester Corporation sent 'a Silver Ewer the gift of Roger Whitley' from the civic plate chest for the four annual communion services celebrated at the Hospital of St John without Northgate, until the church was given a flagon in 1839.

Above all, it was meritorious to give a personal cup for celebrating communion 'in perpetuity'.

Although these gifts are often dismissed as the donor disposing of something of little commercial value and out of fashion, this is to misunderstand the mentality of the times: a handsome old cup, freighted with family associations and memories, was fitting for an ancient building. The parish church was the centre of community life in early modern England and the theatre of social interaction and commemoration. Attitudes to old plate were rich in sentiment; objects carried meanings, even if those are hard to disentangle now.

Most people are unaware of the steady movement in previous centuries from buffets or plate cupboards to vestry chests. But today's strict classification of silver as domestic or liturgical disguises its multi-layered origins. Almost every phase – the High Anglican campaign to beautify worship, the Puritan attack on fonts, Restoration emphasis on restoring furnishings, waves of evangelical enthusiasm in the mid-eighteenth century and even Victorian antiquarianism – drew in such gifts. Local pride, commemoration and piety feature in hundreds of individual histories across England; Norwich

merchants enriched their churches with treasured family plate, as Sir Peter Gleane did in giving his 'sumptuous cup' in 1633 to St Peter Mancroft (fig. 47). A Lincolnshire farmer gave a prize cup won for his fatstock in 1808, 'something like an enlarged claret glass', to Stainsfield church. At the other end of the century, in 1892, a two-handled cup bought with prize money from the Battle of Waterloo and the capture of Paris was given to Thirleby church.

Such gifts were not only seen, and handled, at the great festivals of the Church year, but were also publicly commemorated on benefaction boards, an important element in community recognition. Only the Victorian creation of many new parishes, in-creasing religiosity and simultaneously the commer-cialization of designs for church plate, brought about the relative uniformity we find normal today.

Communicants in large parishes might number several thousand, each taking a good draught, so the jugs to bring the wine had to be capacious. At Hart-land in Devon, twelve gallons and a quart of Canary wine were bought for the Easter communion, the principal festival celebration, in 1614. At St Martin-in-the-Fields in 1616 more than three thousand took Easter communion, at services spread over several days. The churchwardens 'were forced to borrow of vinteners and others, plate to Administer the Holy Sacrament'. This blurring of secular and liturgical use was distasteful to Archbishop Laud. But if new dedicated vessels were bought at parish expense, upgrading to silver 'stoups, pots, flagons or tavern pots to bring wine' was costly. In 1635, when St Martin's churchwardens supplemented their eight

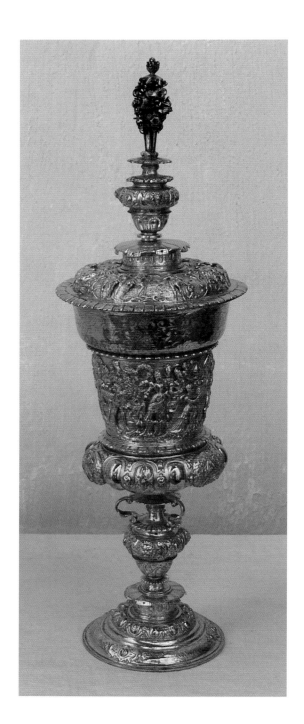

Fig. 47
The Gleane Cup, 1579, maker's mark indecipherable
(given by Sir Peter Gleane in 1633)
(St Peter Mancroft, Norwich)

pewter 'gallon pots, pottle pot and bib'd flagon pots', they spent almost a third of their annual income on three large 'belly pots, double gilt' supplied by the goldsmith William Wheeler. Further capacity was provided for Good Friday 1637 with John Mandrake's gift of a 'bib'd flagon, double gilt', to set beside the pewter ones, and an extra table was bought for the array of flagons, jugs and belly pots at communion. But pewter plates still served to bring the bread.

Occasionally we may glimpse what actually happened during the administration of communion. Some congregations, for example, passed the cup and bread from hand to hand. At Emmanuel College, Cambridge, in 1636, we hear, 'they receive that Holy Sacrament, sitting on forms about the Communion Table and one pull the Loafe from the other, after the Minister hath begun. And soe the Cup, one drinking as it were to another, like good Fellows.'

Decent breaking of the loaf, with the minimum of handling, accounts for the domestic plates, dishes and salvers now scratched with knife marks. In 1638 Alice Whitby, widow of the Recorder of Chester, specified an unusual form of paten, 'a longe silver plate with a foote under it'; when the wafers specified by the Elizabethan settlement vanished from Anglican worship after 1600, new large plates for the bread, often set on trumpet feet, were needed. Memories of convivial feasting during the Commonwealth probably explain the inscription on Mary Jones's large paten, given in 1664 to St John the Baptist Chester, 'to Cary the Consecrated Bred ... to

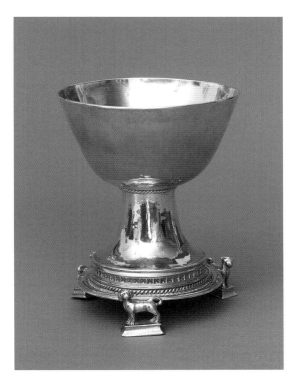

Top: Fig. 48
Cup, silver, late 14th or early 15th century, unmarked (Marston, Oxford)

Above: Fig. 49
Font cup, silver, 1512, maker's mark a barrel (Wymeswold, Leics.)

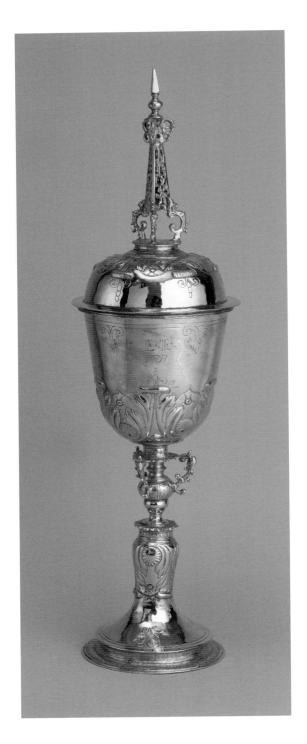

Fig. 50
Steeple cup, silver-gilt, Thomas Flint, 1619 (given in 1707)
Northleach, Gloucs.

be kept Solie for that use and Woe be to those that Commit Sacrilege'.

Rituals of drinking in fellowship have deep roots, and the Protestant communion embodies an act of commemoration. The custom of giving, or leaving, personal drinking vessels affirmed those shared values. When, in 1562, Bishop Horn of Norwich sent a set of beakers to Heinrich Bullinger, chief pastor of Zurich, thanking him for hospitality during his exile under Queen Mary, he used language consciously echoing that of the Prayer Book, writing 'when you daily refresh your remembrance of me in that silver cup'.

Once consecrated 'solely for the Lord's Table', plate served as a material memory as well as a visible manifestation of donors. As community leaders, donors were publicly reinforcing social hierarchy through silver; at communion an array of large matching plate on the altar made a dramatic impression. *The Spectator* in 1710 satirizes this, writing that 'the sumptuous side-board, to the ingenuous eye, has often more the air of an altar than a table'. The writer was clearly familiar with the grand assemblages of plate in the City of London's post-Fire churches.

Some fifty steeple cups, around a third of all those recorded, have been preserved in churches (fig. 50). Although they had fallen out of production by the 1660s, these showy drinking vessels were often valued heirlooms. In 1712 Thomas Farside left a 'silver pointed cordial cup' to his widow Elizabeth, then to their daughter, who married into the Osbaldiston family. After the theft of a communion

cup in 1809, the squire, George Osbaldiston, gave his
great-grandmother's cup to St Matthew, Hutton
Buscel, Yorkshire. A similar story no doubt lies
behind the Elizabethan gourd cup at St Michael and
All Angels, Hinton Admiral (fig. 51). These gifts
sprang from a shared perception: ancient drinking
vessels – such as Elizabethan cups given to St Agnes
Cornwall in 1711, or to Penmynyd, Anglesey, in 1707,
or to a Carmarthen church, again in the early eigh-
teenth century – were fitting for the altar, spoke of
tradition and continuity and, above all, were visible
at a distance. Two steeple cups at All Saints Fulham
made a trio for the altar when a German cup, also
given to the church, had a steeple added to match in
the late seventeenth century.

Widows who owned silver but lacked the finan-
cial resources to invest in perpetuity as men did – by
commissioning a marble monument or setting up a
charitable trust – gave or bequeathed showy old
plate. Two such pieces are Lady Harries's crystal and
filigree cup at Tong (fig. 52) and the Yateley crystal
cup, given in 1675 'for the only use of the Commu-
nion Table'. Another was the 1629 steeple cup left by
Susanna Weedon, a London merchant's widow, who
is commemorated on the rim just where communi-
cants at St John Hampstead would put their lips.
Literally, as the poet Samuel Butler wrote, the
donor's name would be 'on the lips of living men'.

Engraved with arms, these gifts recalled earlier
generations linked to the parish. In 1680 Dulcibella
Harpur gave her first husband's 1635 cup to St
Michael's Chester. Typical are the steeple cup at
Instow, Devon, given by Dionysia Long in 1734 or, a

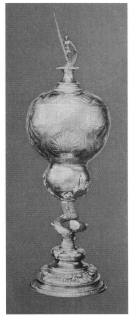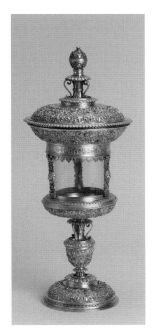

Top left: Fig. 51 Gourd cup, silver-gilt, 1595, maker's mark a branch
(probably given *c.* 1770) (Hinton Admiral, Hants.)

Top right: Fig. 52 Cup and cover, rock crystal and silver-gilt, *c.* 1600,
unmarked (Tong, Shrops.)

Above: Fig. 53 Tankard, silver, parcel-gilt, 1589, maker's mark IM (given
in 1776) (Fugglestone, Wilts.)

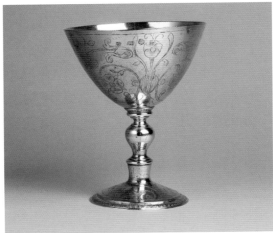

Top: Fig. 54
The 'Boleyn Cup', silver-gilt, 1535, maker's mark three flowers
(St John the Baptist, Cirencester)

Above: Fig. 55
Engraved wine cup, silver-gilt, 1591, maker's mark IN
(Leonard Stanley, Gloucs.)

year later, that given by two sisters-in-law, Jane and Penelope Taylor, to the family church at Welland in Worcestershire. Women crop up again and again as donors. In 1773 Mrs Henrietta Maria Walker gave a 1613 wine cup to Holy Trinity, Tithby, Nottinghamshire, 'for the use of the altar', fulfilling the bequest of her friend Mrs Stanhope 'of the same place'.

Religious language and habits of thought permeated daily life in eighteenth-century England, particularly for women; to be a good woman was to be a good Christian, whereas to be a good man was to be a good citizen, active, self-confident and competitive. Another widow, Dorothy Withers of Hall Place, Deane, granddaughter-in-law of the rector, gave an Edward VI grace cup – appropriately engraved *GIVE GOD THANKES FOR THIS* – to her Hampshire church in 1698. The survival of the bishops' visitation returns, set beside churchwardens' accounts, family papers and the many county inventories, make this a potentially rewarding area of research. But the paper trail may be incomplete: the striking 1535 Masters, or Boleyn, Cup at Cirencester (fig. 54), already belonging to the church by 1633, has defied all attempts to establish how, or from whom, it arrived. Sadly there appears to be no evidence for the tradition that it once belonged to Anne Boleyn or that it was given to the church by Sir Richard Masters, Queen Elizabeth's physician.

Often names, dates or heraldry are handsomely commemorated on the broad curves of flagons and tankards. In 1703 Eliza Bliss left her 1662 tankard to

St Saviour's Southwark, with her arms. In 1744 when
Dorothy Card left Sts Peter and Paul, Mitcham,
'two Silver Decanters which cost me five and Forty
pounds', the inscription referred to her father
William Toll 'late of this parish'. Her flagons are sec-
ular beer jugs, with London hallmarks for 1729. A
pair by de Lamerie made for the Uthwatt family in
the 1730s came to their local church in Bucking-
hamshire a generation later. In Chester in 1729 a
female donor chose for her new church flagon a beer
jug without a lid, a distinctive local form.

Celebrating communion brought the entire
community together, ranked by social hierarchy as
much in their pews as when kneeling around the
altar table. Set out to be seen and even touched, the
consecrated plate kept alive the donors' memory.
Rank was reinforced through the diverse vessels,
often domestic in origin, in which communion was
offered. Hints come from the objects: in Lincoln-
shire the late Canon Peter Hawker listed eleven two-
handled cups dating before 1837. But in New Eng-
land their purpose is more explicit. The informative
diary kept by the Boston judge Samuel Sewall
between 1674 and 1729 records his annoyance at
being crowded by distinguished visitors to the end of
the rail and thus having to take the communion
from a tankard, rather than the higher status chalice.
Boston's churches deliberately acquired many
tankards, beakers and two-handled cups, alongside a
smaller number of chalices, to sustain social distinc-
tions in the administration of the sacrament.

Contemporary practice is documented in Lady
Gooch's 1777 bequest across the Atlantic of her 'gilt

Top: Fig. 56
Standing bowl, silver, parcel-gilt, 1577 (Pontefract, Yorks.)

Above: Fig. 57
Beaker, silver, 1593, maker's mark IM (Howorth, Yorks.)

Sacrament Cup' (fig. 60), in fact a typical late Stuart caudle cup. The Chapel at the College of William and Mary, Virginia, was to retain it in perpetuity, recalling happier times for her between 1727 and the 1740s as wife of a successful Governor of Virginia and mother of a son attending the College. Her two-handled cup had been made by Pierre Harache for her parents ninety years before.

We have little detail of how such two-handled cups featured in English church life, although Presbyterians in Scotland and New England incorporated them into the communion ritual. Their use was not always restricted to religious service and vessels seen as community property no doubt featured in parish conviviality such as the 'feasts, banquets, suppers, church-ales, drinkings … or other prophane usages' criticized by Bishop William Juxon in 1640. At Great St Mary's, Cambridge, the list of occasions for hospitality include the annual audit of the churchwardens' accounts; in 1601 ten shillings was paid 'for a Pottle of Sack that was Drunke in the Chancel'. At Berrington in Shropshire a 'love feast' had been held 'time out of mind' on Easter Day, the incumbent feasting all the parishioners in the church. Under pressure from the patron, in 1639 the bishop agreed to allow it to continue on Monday in Easter week, but not in the church. What would they have been drinking from?

Before the Civil War the Audit Supper, the Election Dinner and wine and cakes after the perambulation, or beating of the bounds, were all held in the church, the largest public building of the parish. Drinking was central to social rituals and often the

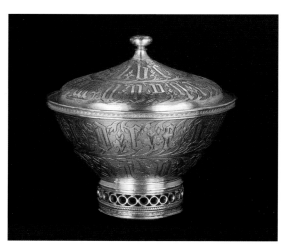

Top: Fig. 58
Mazer bowl, silver-gilt and wood, late 15th century (Lowthorpe, Yorks.)

Centre: Fig. 59
The Studley Bowl, silver, parcel-gilt, *c.* 1400 (given to Aldfield cum Studley church near Ripon *c.* 1872; sold 1913) (Victoria and Albert Museum)

Above: Fig. 60
Two-handled cup and cover, silver, Pierre Harache, 1686
(given by Lady Gooch, 1777) (College of William and Mary, Virginia)

cup, glass or tankard was shared and passed around. Until the 1740s, funerals of rectors in New England were marked with a wake, at which the church flagons, tankards and two-handled cups served as vessels for wine, rum and cider.

Lady Gooch's unusually explicit reference to her cup, and other instances of gently bred widows leaving elaborate old two-handled cups – sometimes with salvers – suggests that these cups had a role at communion. Elderly women perhaps brought a personal cup to take communion in the privacy of their box pews, maintaining their social separation by avoiding the common cup. In 1769 the church of Sible Hedingham in Essex received a 1659 two-handled cup and salver in memory of Ann, Dowager Viscountess Bateman. Five years later, the Hon Elizabeth Forrester left a superb cagework cup and salver to Colerne church; almost a hundred years old, it had been made by Gabriel Felling of Bruton. At Brockhampton a group of plate given by Philip Lutley in 1733 – which includes a two-handled cup made in 1672 – is inscribed *Usui Sacrum Ecclesiae*. But these idiosyncracies of worship are rarely recorded in detail.

The 'decent bason to be provided by the parish' to collect alms, required from 1662, was interpreted differently according to local conditions; some small rural parishes fell back on mazers, as in Essex, or a wine taster, as at St Cyriac Lacock. In the 1630s rosewater basins arrived in certain City churches (fig. 29), followed by domestic dinner plates for the bread in the next hundred years, as pewter plates became distasteful.

Top: Fig. 61
Salver, silver, Benjamin Pyne, 1691
(given by Ambrose Webb in 1702) (Durrington, Salisbury)

Above: Fig. 62
One of a pair of candlesticks, silver-gilt, Jacob Bodendeich, 1675
(given by Peregrine, 2nd Duke of Leeds [1659–1729])(Harthill, Yorks)

Gifts of silver extended to candlesticks for the altar (fig. 62) – an attribute of polite domestic life from the Restoration, they added to the decorum of a midwinter service. In the 1720s Lady Abigail Yeoman gave a forty-year-old pair to St Mary Shrewsbury 'for the use of the Communion', as did Alvia de Veux to St Anne Soho.

Silver basins and ewers for baptism are rare now. A 'skinker', or ewer, given in 1619 to St Werburgh Bristol (now in the Bristol City Museum) was perhaps for this purpose, since a flagon accompanied it, and a large flagon given to St Mary-le-Bow in the 1630s (see Chapter 12) was apparently intended to bring water for baptisms. At the time Bishop Matthew Wren of Norwich was keen to ensure the purity of the font and its water; 'noe dishes, pailes or basins be used in it, or instead of it'. Baptisms were often private. Jugs for water, monteiths and punch bowls were acceptable but fell out of use when baptism at the old stone fonts was re-introduced in the nineteenth century. But they, too, were fitting gifts (see fig. 87). In 1744 a Cheshire widow, Ann Evans, gave a basin 'for the more decent celebration of the Holy Sacrament of Baptism'. At Elstead, Surrey, the font was given as late as 1845, until which point children were baptized in a china basin placed on the communion table.

Fabric and furnishings had been seriously neglected during the Commonwealth, as responses to visitation questions in the 1670s and '80s reveal. In 1674, sixteen parishes in Worcestershire had a broken chalice, four had pewter cups and several none at all; six had no paten and eighteen lacked even a pewter flagon. 'Chalice bruised and unfit for service', a flagon 'old & naught' and a 'trencher used for the bread' are all comments taken from the inspections of churches and parsonage houses in Worcestershire in 1674. In 1686, a visitation in Sussex exposed a similar lack of decent plate. Fourteen parishes in the Lewes archdeaconry had no paten, and cups were 'battered … cracked … much decayed… [or] in pieces'. Pots and flagons were missing or unfit for use. So there was plenty of scope for gifts from local families, keen to be associated with their place of origin.

Waves of intense religious feeling and a growing population in many parishes, coupled with the lamentable situation revealed by successive visitations, meant that in wealthier and larger parishes, old wine cups came to be replaced with larger chalices, perhaps through a parish levy. In 1764 Archbishop Drummond's visitation revealed that fifteen Yorkshire parishes, including Halifax, Leeds, Sheffield, Bradford and Hull, each had more than a thousand households, potentially as many as three thousand communicants. In the manufacturing districts of Staffordshire, as late as the 1830s, the lack of churches had become acute; for a population of 267,000, there were only 71,000 seats. Here new sets of communion vessels of standard form and large size were acquired. But small rural parishes, lacking generous or competitive patrons, were more likely to retain their secular plate. St Nicholas Marston, a small hamlet outside Oxford (31 communicants in 1758), had no resident gentry or parson after the early eighteenth century; although its fifteenth-

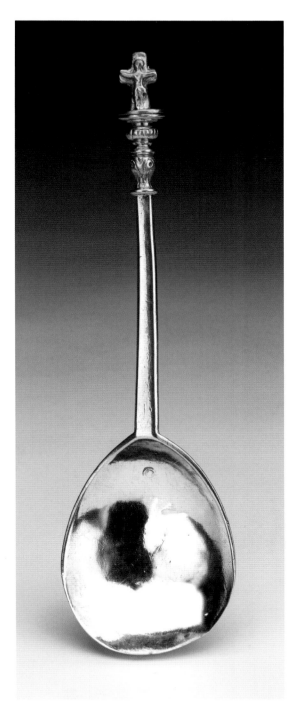

Fig. 63

Spoon, silver, East Anglia, dated 1613

(St Peter per Mountgate, Norwich)

century cup (fig. 48) has no known history, the late George Clarke speculated that it might have come from an antiquarian rector, William Smith, around 1700. St Michael's in Southampton, a tiny parish of three streets, was populous (500-plus in 1725, 1600 in 1788), but its parishioners were poor, so no donor replaced its beautiful 1560s cup chased with Rebecca and Isaac (now in the Southampton City Art Gallery).

Kept locked away in the bank, incurring the burden of storage and insurance, or lent to a museum, such objects are often dismissed as inconvenient, unusable and irrelevant. But these survivals offer rich insights into the psychology of donors, the value set on commemoration in perpetuity, and the diversity of local practice. Examples are the beakers found in the East Midlands, or the many strainer spoons recorded in Bristol and London parishes. In the City of London in the 1890s Edwin Freshfield listed 58 dating between 1631 and 1852. In 1684 the churchwardens of St Benet Fink purchased a fashionable trefid spoon, and had it half-pierced, for 18s 6d, with a case included in the price. This concern for the quality of the wine is perhaps explained by the presence of professional vintners in Bristol, and prosperous wine drinkers in London, sharing an appreciation of what they drank which was missing in less sophisticated communities.

Other spoons, unpierced (fig. 63), were required for the practice of high churchmen and Non Jurors of 'putting thereto in the view of the People a little pure clear water' to the wine, as at All Hallows Barking before 1720. The use of knives to cut the bread is

evidenced by the heavily scored surface of many domestic dishes serving as patens, such as a pierced Jacobean sweetmeat dish given by Lady Barnardiston to an Essex church. These survive in several churches, although the late nineteenth-century reappearance of wafers made them redundant: a handsome gilt one, together with a knife, was part of Mrs Strangways Horner's gift to five Dorset and Somerset churches in 1755 (fig. 75).

Fig. 64
Cup and cover, silver-gilt, 1635, maker's mark ES
(given by Sir Thomas Richardson when new)
(Goldsborough, Yorks.)

Some in the Church of England today are embarrassed by the possession of such valuable and, it is argued, redundant objects. However, once they are out on the market, even if acquired by a museum, their liturgical significance is quickly forgotten and our understanding of the subtle varieties of Anglican practice is weakened. Between 1966 and 1969, a flurry of high-profile sales by churches of early tankards, beer jugs, flagons and steeple cups raised concern. In the 1971 Tredington Judgment, the churchwardens of St Gregory, Warwickshire, appealed to the Court of Arches when denied a faculty to sell a pair of late Elizabethan domestic livery pots, given in 1638 by the rector. Chancellor George Newsom laid out the principles which have governed and in effect limited disposals over the past thirty-five years. A faculty to sell 'should seldom be granted … [and] some good and sufficient ground must be proved'. Redundancy alone is not enough justification and expert witnesses must be invited to argue against the petitioners. However, financial pressures have grown as congregations shrink. In 2006 the Chancellor of Lincoln diocese, reluctantly authorizing the sale of a late Stuart two-handled cup and salver, pessimistically pointed out that 'the life expectancy of many Grade I country churches is very limited'.

It was inevitable that by carefully recording church plate, antiquarian-minded scholars would bring collectable objects to an eager market. Already in 1870 Octavius Morgan commented on sales of old plate from churches and Braithwaite listed some 28 secular objects still owned by Hampshire churches

while regretting past sales. Of these 28, a fifteenth-century cup from Kimpton is now in the Victoria and Albert Museum, the Deane Cup belongs to the Hampshire County Museum Service and the Elizabethan cup from St Michael's Southampton has passed to the City Art Gallery. But an important initiative in 1913 did much to stem the tide of these church sales. It was the proposed sale to an American collector in that year of a late fourteenth-century pottage bowl from a Yorkshire church, presented as recently as 1872, which triggered public outrage and a campaign in the letter pages of *The Times*. As a result the Studley Royal Bowl (fig. 59) was bought for the Victoria and Albert Museum and the museum set up the first Church Plate Loan Gallery, as a safe location for objects seen as surplus to current needs or too valuable to use. In the late 1950s the growing security and insurance burden of historic and increasingly valuable plate was recognised. In the following decades a series of treasuries (see Chapter 13) was created in secure locations in Anglican cathedrals and larger churches such as Newark.

Top right: Fig. 65
Cup and cover, silver-gilt, late 15th century, unmarked
(Fareham, Hampshire)

Right: Fig. 66
Covered beaker, silver-gilt, William Hornblowe, 1577
(Honington, Lincolnshire)

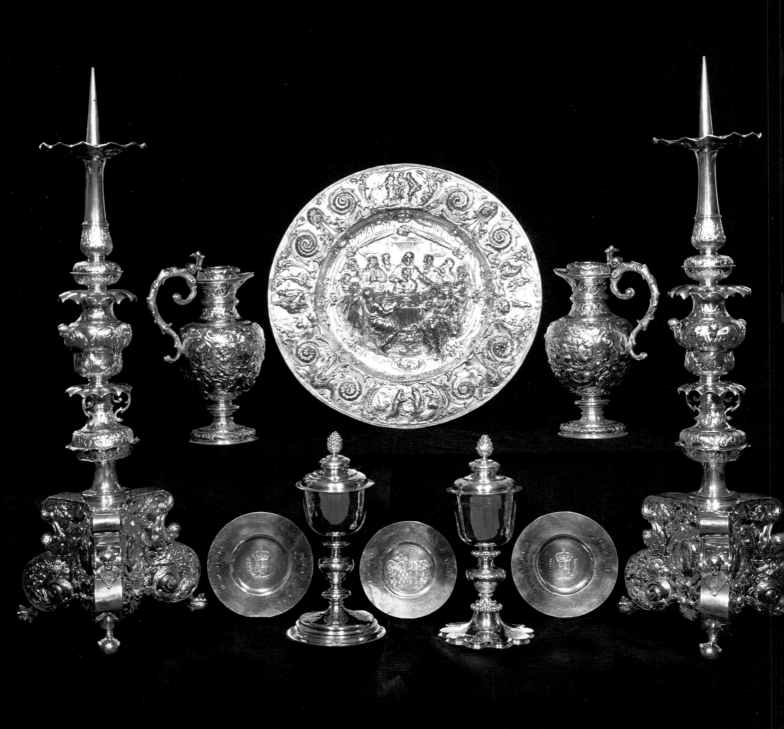

Fig. 67 The Auckland Castle plate, silver-gilt, commissioned by Bishop John Cosin of Durham, *c.* 1660 (Bishop Auckland, Durham)

A Broad Church
Sacred Silver in the Seventeenth
and Eighteenth Centuries

William Jacob and James Lomax

By James I's accession in 1603 most parishes provided a silver communion cup, with a cover to serve as a paten, to celebrate the holy communion. So much may be inferred, although we have no positive documentary evidence for it, from Canon 20 of the Canons of 1604, which makes no reference to providing communion cups and patens, only requiring that wine should be brought to the altar in a 'clean and sweet standing pot [flagon] of pewter or other pure metal'. After some decades of uncertainty the Church of England was now entering a more stable phase, providing goldsmiths, chasers and engravers with opportunities to develop and decorate new forms of vessels, unparalleled in the Catholic tradition, to meet the Church's liturgical and pastoral needs. Expensive gifts of silver for the Church hint at the spiritual and aesthetic sensitivities of the laity who presented them and how they valued their faith and the sacraments. The quantity and quality of plate given to churches during this period was extraordinary, matching that of the medieval period.

Controversies in the early Stuart Church:
Communion cups

At the Hampton Court Conference in 1603 James I sought to establish a *via media* reflecting the Catholic as well as Reformed polarities in the established Church (a tendency inherent in the Elizabethan Settlement), especially in the Prayer Book, which was reissued with minor revisions in 1604.

These polarities are partly reflected in the design and decoration of communion cups and other altar plate. For most parties occupying the broad middle ground the Elizabethan communion cup, with its deep bowl and paten cover (see Chapters 3 and 4), was acceptable. Indeed, this basic design remained standard, with variations, to the end of the seventeenth century, and with conservative minded congregations until much later. To one side of this, however, the more Reformed tradition emphasized the Lord's Supper as a simple sharing of bread and wine in memory of Christ's death, and adherents of this tradition may have preferred to use vessels based on secular models (some of which

were actually of domestic origin). These included baluster-stemmed wine cups or beakers such as that in fig. 57 or the example of 1598 at Walesby, Nottinghamshire (a notorious place of dissent from which people departed to a new church order in New England). These were similar to those used by Continental and Scottish Calvinist churches and their congregations in England – for example, the Dutch congregations in Norwich and London. Partisans of the Catholic tradition, on the other hand, identifying the Church of England with what was called the 'primitive' Church, tend to be associated with Gothic Revival communion cups (or 'chalices') modelled on medieval examples.

The earliest datable example of this kind was made for St Mary Extra Southampton in 1620, paid for by contributions given at the church's consecration by Bishop Lancelot Andrewes. Not all chalices made for the High Church party were in this style, however, and others given by Archbishop Laud and Duchess Dudley to Trinity Chapel Knightsbridge, Manningtree parish church and elsewhere were modelled on Elizabethan communion cups.

Figurative representations on communion plate (as in stained glass) are also associated with the High Church party, and begin to appear from as early as 1607 with a Crucifixion scene on chalices presented to Melbury Sampford in Dorset and at Weston St Mary in Lincolnshire in 1611. The Three Maries appear on a chalice given to Beddgelert, North Wales, in 1610 by Sir John Williams, goldsmith to the king, while St Werburgh's, Bristol, had a standing cup of 1619 with a representation of St Peter engraved inside the bowl. The image of the Good Shepherd, perhaps derived from a description of an early chalice by Tertullian, may have been a mark of the Catholic tradition, but was also a favourite image of 'evangelical' bishops. Bishop Lancelot Andrewes had such a chalice in his chapel at Winchester House, the High Church chapel par excellence, and another of about 1615 is at St John's College, Oxford. A flagon at Severn Stoke in Worcestershire, marked 1618, shows the figure in contemporary costume.

Flagons and services of altar plate

The 1604 Canons requirement for a 'pot' or flagon for the celebration of the holy communion was a practical response to the need for large quantities of wine on the altar now that the laity received wine as well as bread at the sacrament. In many towns even a large communion cup could not have contained sufficient wine for the number of potential communicants. Although the Prayer Book provided for additional wine to be consecrated if it ran out, this was clearly thought unsatisfactory, so the custom was commended of also consecrating wine in flagons.

Thus from 1605 archbishops and bishops, at their periodic visitations of their provinces or dioceses, enquired, like Archbishop Bancroft, whether they 'doe provide against every communion … good and wholesome wine … to be brought in a cleane and sweete standing pot of pewter or of other pure mettle'. Archbishop Abbot, in 1612, speaks of 'a flagon of silver, tinne, or pewter, to put wine in, whereby it may be set upon the communion table, at the time

of the blessing thereof', confirming that wine was consecrated in flagons. The reason for his concern over the appropriateness of these vessels is spelt out by Bishop Matthew Wren's 'Orders' for his visitation of his Norwich diocese in 1636, in which he directed 'that no wicker bottles or tavern potts bee brought unto the communion table'.

Town parishes therefore, especially if they contained only a single parish church, began to acquire silver flagons, in addition to a second or more communion cups. Early examples, such as those acquired by Wells Cathedral (1572), Cirencester parish church (1577), and St Margaret's Westminster (1584), were based on designs for vessels displayed on the buffet in houses. These include bellied or pear-shaped 'livery pots' (fig. 32), followed slightly later by 'spout pots' with long straight or curving spouts (fig. 33), and then by tall, straight-sided tankard-shaped cylindrical vessels which assumed the name of flagons (fig. 34). Apart from inscriptions or engraved imagery, or a cast cherub as a thumbpiece, they are usually indistinguishable from their domestic equivalalent. Although the secular models on which they are based soon became outmoded, like communion cups derived from Elizabethan drinking vessels, Jacobean-style flagons continued indefinitely as part of the classic repertory for the altar.

This addition to the silver for the sacrament gave an opportunity for donors to provide services or sets of pieces with a unified visual language, illustrating yet further the renaissance of interest in the altar and its furnishings. After about 1608 they

Fig. 68 Covered paten, silver-gilt, John Plummer, York, 1674 (Ripon Cathedral)

become much more common, for example the set made that year for All Hallows Great Thames Street in the City of London. By the 1630s they were quite common in all ecclesiastical contexts, witness the trio given to Much Marcle by the grand-daughter of Edward VI's tutor, Mrs Ann Walwyn, 1638–41, comprising cup and paten cover, flagon and additional paten, in a plain 'Elizabethan' style (fig. 69). All donors valued good-quality plate.

In addition to flagons, patens in the form of large plates on a foot were frequently given to town churches, to accommodate the large quantities of household bread required. In the late 1620s a bowl-like paten appears, for example at Kingham in Oxfordshire in 1629. In the 1630s Duchess Dudley, who provided gifts of silver to eleven parishes with which she was associated over a forty-year period,

ordered a covered paten, comprising a standing bowl with a cover which, if reversed, could serve as a paten. The earliest examples are her gifts of about 1631 to Ladbroke and Monks Kirby in Warwickshire, which are embossed with cherubs, fruit and the instruments of the Passion. After the Restoration a further experiment is the standing paten and domed 'aire' or cover made as part of a large new service by John Plummer of York for Ripon minster in 1672 (fig. 68).

The Caroline Church

James I's *via media* for the Church of England proved difficult to maintain, partly owing to

Fig. 69 Communion cup, silver, 1638 (Much Marcle, Herefordshire)

Continental influences following from the Synod of Dort in 1618 and the outbreak of the Thirty Years' War, which led to a polarization between the Reformed and Catholic strands in the established Church. From the 1610s clergy associated with the Catholically inclined Lancelot Andrewes and John Buckeridge started to gain the ascendancy and were increasingly appointed to deaneries and subsequently bishoprics. The most notable of these was William Laud, who was Archbishop of Canterbury from 1633 until his execution in 1645. When Laud became Dean of Gloucester in 1618 he moved the communion table to the place the pre-Reformation altar had occupied, as in Andrewes's chapel at Winchester House, which Andrewes may himself have copied from St Giles Cripplegate, where he was rector and which had had an altar rail early in Elizabeth's reign. This arrangement, with the communion table standing altarwise against the east wall of a church or against a reredos, allowed for a display of silverware associated with an orderly and ceremonial celebration of the holy communion. This had always been the custom in royal chapels and some cathedrals, but now a group of clergy and influential laity encouraged wider developments. In the plan of Bishop Andrewes's chapel (fig. 72) the 'bason for oblations' was propped against a cushion, in the middle of the communion table, between the candlesticks, where, before the Reformation, the cross would have been. This and the accompanying list and valuation of the plate ('all gilt'), illustrates the magnificence aimed at in furnishing an altar.

During the 1620s and '30s many cathedrals, college chapels and some parish churches acquired magnificent sets or services to celebrate the holy communion, comprising pairs of chalices, patens, flagons, at least one alms dish, matching elaborately bound folio copies of the Bible and Prayer Book, and candlesticks. The most splendid such service was that given by Charles I to St George's Chapel, Windsor. This was made by Christian van Vianen; it amounted to 2,807 ozs and was chased with scriptural subjects but was melted down soon afterwards at the onset of the Civil War. The splendour of the service in a church or chapel, envisaged as the court of heaven, should, it was thought, equal that of the

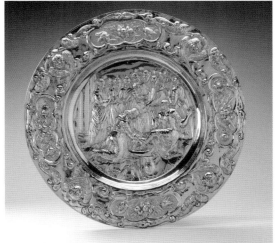

Fig. 70 The 'feather' flagons, 1662, maker's mark TB (given by Anne Hyde, Duchess of York) (St George's Chapel, Windsor)

Fig. 71 Altar dish, silver-gilt, *c*. 1660, unmarked, embossed with *The Washing of the Feet* (St George's Chapel, Windsor)

Fig. 72 Plan of Launcelot Andrewes's Chapel,
from *Canterburies Doome* (1646) (Victoria and Albert Museum)

king's court. In a cathedral or incorporated town,
the magnificence of the silver on the communion
table in the cathedral or parish church should equal
that at the mayor and common council's banquets.
Boroughs rich in civic treasure and regalia often
have parish churches rich in plate.

Members of Bishops Andrewes's and Neile's
circles, moving into positions of power in James I's
later years and under Charles I, emphasized the
Catholic tradition of the English Church at the
expense of the Reformed tradition, which had
hitherto become mainstream outside court and
university circles (see illustration from *Eniautos,*

or a course of Catechising, fig. 73). Some new bishops
enforced canons and rubrics formerly regarded as
permissive. This led to the greatest change in church
interiors since the upheavals of the 1530s–60s. In the
1630s the location of the communion table, and its
railing in – to protect it from profane use, especially,
it was said, by dogs – became a matter of bitter dis-
pute in parishes and a significant contributory factor
to the outbreak of the Civil War in 1642. However,
while these controversies were the cause of acri-
monious and violent disputes in parishes, the holy
communion itself was rarely reported to be paro-
died or profaned, and eucharistic vessels are seldom
mentioned, other than an Ordinance of 1644 which
required parish officers and justices of the peace to
deface – amongst many other 'monuments of idol-
atry and superstition' – images on church plate.

The Civil War and Interregnum

The Interregnum was a time of mixed fortunes.
By the Civil War many rural parishes had more than
made good the silver they lost at the Reformation.
Not many parish churches lost plate during the Civil
War and the Commonwealth (having avoided the
forced 'loans' of plate to which collegiate and institu-
tional bodies had been subjected) and some contin-
ued to receive significant gifts. But cathedrals,
having no function in a fully Reformed church in
which bishops had been abolished in 1642, were
stripped of their plate. Parliamentary armies sacked
Winchester and Chichester Cathedrals in December
1642, and Prince Rupert's men robbed the plate from
Lichfield in April 1643. The House of Commons

ordered the sale of the silver at St Paul's and West-minster Abbey in 1644; the Corporation of Norwich seized the cathedral plate, and the Lord Mayor of York removed the candlesticks and patens from the Minster.

Although the Prayer Book was forbidden in parish churches by Parliament (being replaced by *The Directory for the Public Worship of God*), some sequestered royalist Anglicans fitted up private chapels and provided magnificent services of plate for their altars. Sir Robert Shirley equipped his new chapel, built like a parish church alongside his house at Staunton Harold in Leicestershire with two Gothic Revival chalices and covers, a pair of covered flagons, a pair of candlesticks and an alms basin. The Duke of Richmond and Lennox commissioned a magnificent service for his chapel at Cobham Hall. This was subsequently given by Sir Joseph Williamson to Rochester Cathedral. The Shirley and Lennox services are marked by the same goldsmiths, Robert Blackwell father and son, who supplied some of the finest plate at this time.

The Restoration

Following the restoration of the king and bishops in 1660, places which had lost their silver during the Civil War were quick to replace it. Large distinctive pieces, including candlesticks, 'feathered' flagons (maybe echoing pre-Civil War pieces), altar dishes and alms basins embossed in high relief – the largest with a virtuoso scene of the Last Supper by Wolfgang Howzer – were ordered for the Coronation and the Chapels Royal (figs. 70 and 71). This subject was

Fig. 73 'The Lord's Supper', from *Eniautos, or a course of catechizing* (1674) (British Library)

also used by the same goldsmith on the altar dish for Bishop Cosin's new service at Auckland Castle, decorated in the auricular style (fig. 67). Christ Church Cathedral, Oxford (fig. 74), and Gloucester Cathedral acquired nine-piece services almost immediately, and by 1665 many others had become exemplary in their silver for worship according to the

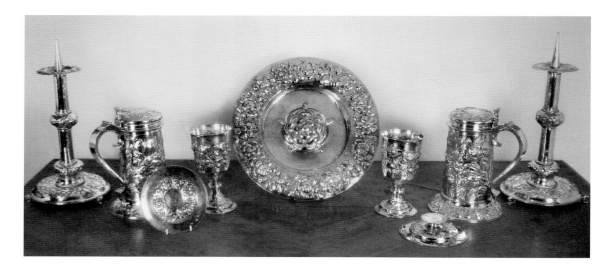

Fig. 74 Dean Fell's altar service, 1661, maker's mark PB (Christ Church Cathedral, Oxford)

rubrics of the newly revised Book of Common Prayer. By 1699 St Paul's had two chalices with covers, two patens, four flagons, five altar dishes, four candlesticks and a silver-mounted Bible and Prayer Book.

Altar dishes or 'basons' were now a recognized part of altar furniture in cathedrals, wealthy collegiate chapels and churches. So too were candlesticks, often taller and quite distinct from secular examples, with prickets to support tall tapers, as used 'in many cathedral churches, besides the chapels of divers noblemen'. Altar dishes could double up with alms dishes or basins, which had begun to appear in James I's reign.* The rubrics for communion in the 1662 Prayer Book directed that an appropriate person should receive the 'Alms for the Poor, and other devotions of the people, in a decent bason to be provided by the parish for that purpose and reverently bring it to the Priest, who shall humbly present and place it upon the holy Table'. Elaborately decorated alms dishes were as important an item of sacramental plate as the vessels in which the bread and wine are offered. Alms basins and altar dishes represent a uniquely Anglican contribution, unknown elsewhere in the universal Church.

The theology and liturgy of the pre-Civil War High Church tradition had now become the Anglican mainstream. The 1670 Act for rebuilding City churches after the Fire of London required communion tables to be placed altarwise, and railed. Most were backed by carved reredoses under elaborate plaster ceilings, replete with eucharistic imagery. By the end of the century in most English churches communion tables were similarly placed. New churches in Westminster and the poorer parts of London were built on a magnificent scale and suitably equipped with silver services. The Duke of St Albans, founder of St James's Piccadilly, in 1684 gave four chalices, four patens, three flagons and an altar dish. By 1750 St Martin-in-the-Fields had six chalices

*The chapel at Longleat has a basin of 1619, engraved *he that giveth to the poore lendeth to the Lord; and the Lord will recompense him that which he hath given,* with a cast medallion of Christ washing the disciples' feet in the centre.

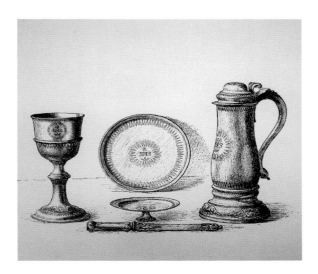

Fig. 75 Altar service, silver-gilt, Paul de Lamerie and Daniel Piers, 1748 (given by Mrs Strangeways Horner in 1755) (Abbotsbury, Dorset)

Fig. 76 Collecting shoe, silver, 1728 (Gressenhall, Norfolk)

with covers, three chalices and covers for administering holy communion to the sick at home, three standing patens, seven flagons, three alms basin, one baptismal ewer, one spoon and one knife, all gilt.

Gifts of the laity

The late seventeenth century was a period of growing prosperity. Gentry, aristocracy and wealthy merchants adorned their parish church communion tables as well as their sideboards. The period from 1680 to 1750 saw a particular burst of generosity by lay people in providing silver for sacramental use in parish churches, which in a range of English counties considerably exceeds the numbers of pieces given over the same span before or after. Sometimes groups of people clubbed together to buy a flagon or an alms dish. At Hedenham in Norfolk the rector persuaded the better-off parishioners to contribute to buy a new paten, and then a 15-guinea flagon for the parish church. Some individuals were enor-

mously generous, especially women. We have already noted Duchess Dudley and her gifts. Her daughter, Lady Frances Kniveton, in 1640 gave similar sets to five churches on her husband's estates in Derbyshire. At Newark parish church in 1705 Lady Frances Leake gave a set of six flagons, two communion cups with patens, an alms dish and a pair of candlesticks, weighing in all 700 oz. At her death in 1739 Lady Elizabeth Hastings of Ledsham in Yorkshire bequeathed money to provide the seven parishes in her patronage with sets of chalice, paten and flagon, each set weighing 66 ozs. Mrs Strangways Horner gave similar sets to five Dorset and Somerset parishes (fig. 75), including instructions on how to clean the silver. (See also the discussion of women benefactors on pp. 53-56).

Additional items of plate began to be given too, including, from the early seventeenth century onwards, strainer spoons and, from 1660, silver-handled bread knives (fig. 75). In the eighteenth

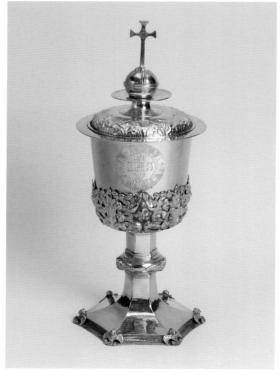

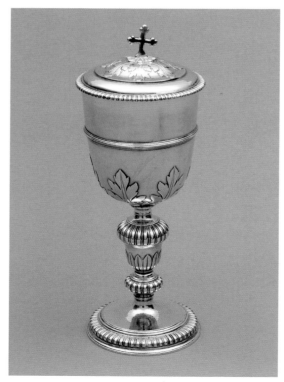

century parishes were occasionally given silver col-
lecting trays or 'shoes' for collecting alms at the
offertory in the holy communion service (fig. 76).
Many London churches acquired silver-topped
staves for parish clerks and, in pairs, for church-
wardens.

In towns there were monthly, or more frequent,
communion services. In Leeds the vicar reported
to Archbishop Drummond in 1764 that 'The Sacra-
ment of ye Lord's Supper Communion is adminis-
tered abt 18 times in ye year in the Parish Church ….
There may be abt 10,000 Communicants within the
Township … abt 600 of whom at an average do
communicate …. At Easter last abt 1700 did com-
municate.' All six of the parish's extremely com-
modious flagons and eight cups and patens would
have been needed. In this church one 'Elizabethan'-
style cup of 1610 survived from before the Civil War
and was deliberately copied for the seven additional
cups provided between 1676 and 1731. Similarly all
the flagons were modelled on the earliest example,
dating from 1676. The altar would have presented
a scene of considerable splendour and visual unity.

At the nearby semi-rural parish at Whitkirk,
with 700 souls and 200 regular communicants, there
were nine communion days each year in the mid
eighteenth century, at which approximately ten gal-
lons of wine were consumed (costing the parish
some £3 5s 0d). The secular wine cup of 1606, made
by the royal goldsmith John Acton and given to the
church in 1666 by the 1st Viscount Irwin, was
augmented by two massive flagons given by his
grandson in 1742.

Fig. 81 Holy communion in a fashionable church,
from Edward Ryland, *The Liturgy of the Church of England* (1755)
(Victoria and Albert Museum)

Facing page
Top left:
Fig. 77 Chalice from the Fell altar service (fig. 73), silver-gilt
(Christ Church Cathedral, Oxford)

Top right:
Fig. 78 Flagon from the Durham altar service (fig. 82), silver-gilt, Francis
Butty and Nicholas Dumée, 1766 (Durham Cathedral)

Lower left:
Fig. 79 The Countess of Huntingdon's chalice, silver-gilt, 1670
(Lichfield Cathedral)

Lower right:
Fig. 80 Communion cup and cover, silver-gilt, John Chartier, 1699
(Christ Church Cathedral, Oxford)

Fig. 82 The Durham Cathedral altar service, Francis Butty and Nicholas Dumée, 1766 (Durham Cathedral)

Styles

One reason for the long life of plain 'Elizabethan'-style communion cups and 'Jacobean'-style flagons may be because copies or replicas of venerable heirlooms were often preferred to modern styles in order to create tangible links with the past and to create a harmonious effect on the altar. But this plain style never entirely ossified, for goldsmiths developed subtle variations on even the most unadorned objects. Thus, like several other early eighteenth-century goldsmiths, Paul de Lamerie heightened the stems of his cups and employed horizontal mouldings on the foot, stem and bowl to provide a satisfying balance between the vertical and horizontal tensions of the vessels (fig. 75). Gothic continued to be

used too: Oman noted over seventy communion cups in this style up to the end of the seventeenth century. Cluster columns were eminently suitable for altar candlesticks as an alternative to Baroque balusters. Rococo Gothic, although often used for church furnishings in the mid eighteenth century, is surprisingly rare, apart from the exceptional new service for Durham Cathedral by Butty and Dumée of 1766 (fig. 82). Here the matching pieces are united by their elegant double bombé forms and naturalistic decoration incorporating a sinuous ogee motif.

Elsewhere the decoration of sacred plate generally followed secular trends but with appropriate iconography. The high-relief embossed decoration characteristic of Restoration plate provided winged

angels or cherubim, garlands of vine leaves on cups or flagons, and pictorial scenes from Scripture on alms or altar dishes. Other late seventeenth-century secular features are cagework (fig. 79), alternate spiral fluting and gadrooning, and even – uniquely – flat-chased chinoiserie (fig. 84).

The arrival of Huguenot goldsmiths in London in the late seventeenth century introduced a new confidence and opportunities for stylistic development. Jean Chartier's elegant cup of 1699 from Christ Church, Oxford (fig. 80), with its balanced proportions, baluster stem, rich mouldings and cut-card work, is a fine example of subdued French Baroque classicism, now subtly anglicized. Flagons were made in the form of pear-shaped jugs, differentiated from hot-water jugs or beer jugs by being larger in scale and engraved with the sacred monogram or the donor's armorials (fig. 78). This style, seen at its most sophisticated in the chapel plate at Dunham Massey, was highly suited to the dignified and measured Georgian liturgy (see illustrations from Ryland's *Liturgy of the Church of England* [1755]; fig. 81). By the mid century some basic shapes had become more rounded, and decoration might sometimes include a degree of naturalism, as at Durham Cathedral, but otherwise the full-blown Rococo style did not sit easily with the ethos of the Georgian church.

Much less silver was given to the Church after about 1760, and there is relatively less new church plate in a consciously Neoclassical idiom despite the style's popularity and suitability for secular plate. Nevertheless, major architects such as Sir William Chambers and James Wyatt provided designs for

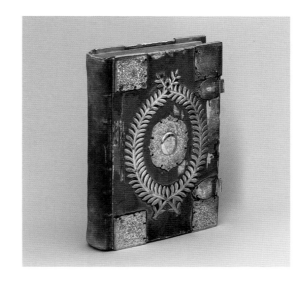

Top:
Fig. 83 Silver-mounted Bible, 1638 (Christ Church Cathedral, Oxford)

Above:
Fig. 84 Communion cup and cover, silver, 1688, maker's mark IE (anonymous parish church)

church plate in the 'antique' taste for discerning patrons. Chambers's remarkable service in the Greek Revival style for Blenheim Palace (fig. 85) is probably unique, while Wyatt's designs were realised on a number of occasions by Matthew Boulton (fig. 86). Surprisingly the newly fashionable and cheap alternative medium of Old Sheffield Plate found little enthusiasm.

One characteristic of late eighteenth-century Neoclassical silver is the relative fragility of its forms, which may have made it unsuitable for liturgical handling. With the return of 'massiveness' as a characteristic of secular plate in the early nineteenth century, church plate followed suit. When allied with a discriminating patron and inventive goldsmith – such as the Duke of York and Paul Storr in a service for the new St Pancras church in Euston Road, London, in 1822 – the effects could be astonishing.

Fig. 85 Chalice, silver, Parker and Wakelin, 1768 (designed by William Chambers) (Courtesy of the Trustees of the Marlborough Chattels Settlement)

Fig. 86 Chalice and ciborium, silver, Matthew Boulton, Birmingham, 1774 (Gunton, Norfolk)

Fig. 87 Christening bowl, silver-gilt, Thomas Whipham, 1743 (given by Miss Sarah Adey when new) (St Mary's Lichfield)

Fig. 88 Holy communion in the early eighteenth century, from Charles Wheatly, *The Church of England man's companion* (1714) (British Library)

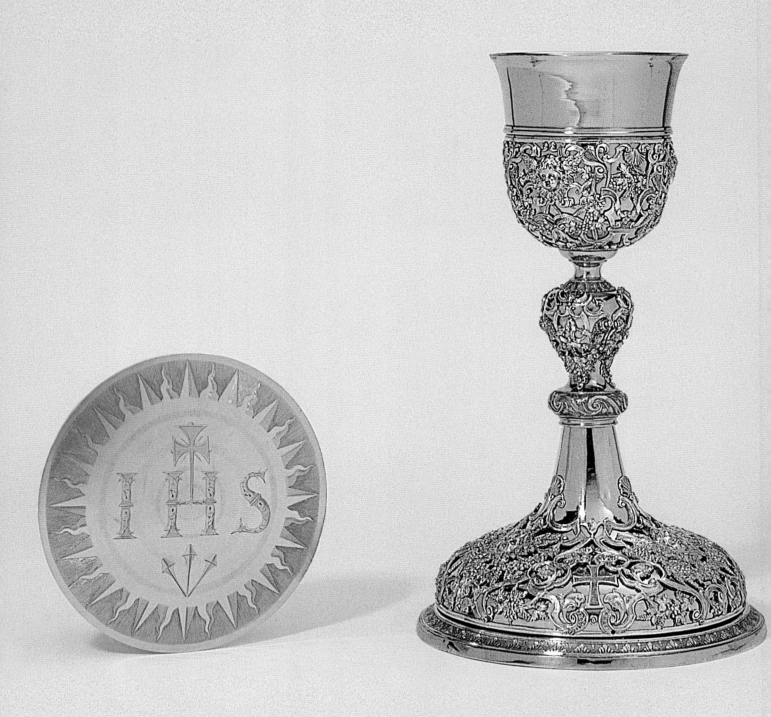

Fig 89 Recusant chalice and paten, silver, parcel-gilt, *c.* 1735, unmarked, attributed to Charles Kandler, made for the 8th Baron Petre
(Bishop of Brentwood, on loan to the Victoria and Albert Museum)

Recusant Plate in England

Tessa Murdoch

After the Reformation, the Roman Catholic faith in England was severely restricted. Catholics who refused to attend Church of England services were known as recusants; publicly they declared themselves non-conformists. During the seventeenth century they were affected by a series of increasingly restrictive laws known collectively as the Test Acts. Under the first of these, the Corporation Act of 1661, anyone refusing to take communion under the Church of England rite was debarred from holding public office; under the Conventicle Act of 1664 Catholics and non-conformists alike were banned from attending unauthorized religious meetings and, under further legislation in the following decade, office holders and members of Parliament were required specifically to deny the doctrine of transubstantiation. As a result, there was almost no opportunity to attend a public celebration of the Mass or other Catholic rite in England and, until the late seventeenth century, Catholics had to worship in private.

There were exceptions to this, however, especially in London and for the Catholic aristocracy on their landed estates. In London a special situation existed in that Catholics could worship openly in the chapels of the Bavarian, Portuguese, Spanish and Sardinian embassies. During the reign of Charles II (1660–85) Catholic courtiers could also attend the Queen's private chapel and that of the Queen Mother, Henrietta Maria, at Somerset House. On Easter Sunday in 1666 Samuel Pepys did exactly that, commenting in his diary that 'their mass … was not so contemptible, I think, as our people would make it, it pleasing me very well'.

Charles II was tolerant of Catholics but his brother James II (r. 1685–88) was openly Catholic in his devotions and his brief reign gave his co-religionists the further opportunity of legitimately attending services in the newly built chapel at Whitehall Palace in London and at Holyrood Abbey in Edinburgh. In a new spirit of confidence Catholics all over the country opened chapels for public worship. Nor was their optimism entirely dashed after the accession of William and Mary.

The Conventicle Act of 1664, which had banned religious meetings outside the established Church,

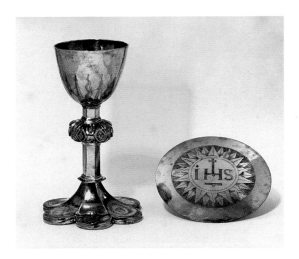

Fig. 90 Recusant chalice and paten, silver-gilt, *c.* 1650, unmarked
Formerly used in the chapel at Coldham Hall (Old Coslessey, Norfolk)

exempted members of the same household, making
it possible for the relatively small number of aristo-
cratic Roman Catholic families to maintain a private
chapel within their houses. The Dukes of Norfolk at
Arundel Castle in Sussex, the Arundells at Wardour
Castle in Wiltshire and the Petres at Ingatestone and
Thorndon in Essex all owned chapels and used them
to nurture local Catholic communities. Catholic
families slightly lower down the social scale main-
tained chapels, too. In the seventeenth century, for
example, Robert Rookwood installed in Coldham
Hall in Suffolk a secret chapel in the attic which led
off the Long Gallery on the upper storey.

But for ordinary Catholic believers and espe-
cially for priests the oppressive anti-Catholic laws in
England dictated a more secretive and precarious
existence, with a constant need to conceal the evi-
dence of their faith. The plate made for recusant use
from the first half of the seventeenth century reflects
this need for concealment. It is limited in range and

restricted to the essential items for the mass –
mainly chalices but occasionally paxes and pyxes.
It is seldom hallmarked, unless its true ecclesiastical
purpose could be concealed (since exposing such
objects to public gaze in the assay office at Gold-
smiths' Hall would have brought its own risks).
For the same reason chalices tended to be made so
that they could be unscrewed into several parts for
easy concealment. Typical of this type of chalice is
one of about 1630 formerly used at Coldham Hall
(fig. 90). Its form is reminiscent of a medieval chal-
ice and it is finely engraved on the foot with the
instruments of the Passion.

The renewed confidence that came with the
changing political situation in the late seventeenth
century can also be seen in the recusant plate made
around that time. Not only is this more frequently
hallmarked than before, but the range of items has
expanded to include sanctuary lamps, cruets and

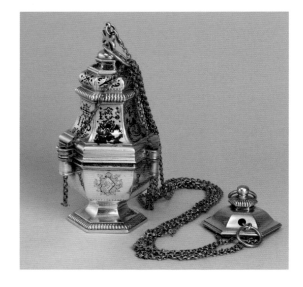

Fig. 91 Censer, silver, Anne Tanqueray, 1732
(St Dominic's Priory, London)

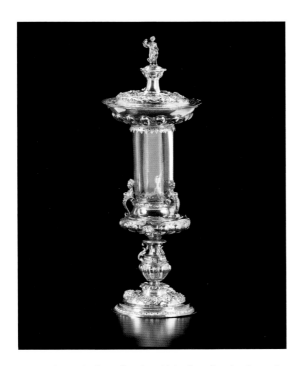

Fig. 92 Reliquary (perhaps of secular origin) , silver-gilt and rock crystal, Affabel Partridge, 1551 (on loan to the Victoria and Albert Museum)

close connections with European Catholic institutions provided the lifeblood of spiritual training, while intermarriage between Catholic families helped to provide the capital to pay the expense of maintaining a private family chapel.

An example of these connections is provided by the story of a recently discovered silver-gilt and rock-crystal reliquary which originated in England in the sixteenth century. The reliquary (fig. 92) was hallmarked in London in 1551 and bears the maker's mark of Affabel Partridge, who served as Royal Goldsmith to both Mary and Elizabeth. The vessel was given to the Poor Clares in Rouen by Lady Browne on behalf of her husband Sir Charles in 1737. The eighteenth-century *Chronicles of the Poor Clare*

incense boats. Monstrances, one of the great showpieces of Catholic altar plate, were imported from France and referred to by the French term 'soleil'.

Ironically, in some ways the legal restrictions placed on Catholic families throughout the seventeenth and eighteenth centuries gave them a vitality and cohesion that they might not otherwise have had. Excluded from the English universities, for example, the sons of the Catholic nobility and gentry were educated at colleges in France, Germany and the Low Countries. As early as the late sixteenth and early seventeenth century many trained for the priesthood at Douai, Rome and Louvain and in Spain at the English colleges in Madrid, Seville and Valladolid. Daughters entered the Benedictine convent at Ghent and the Poor Clares at Rouen. Such

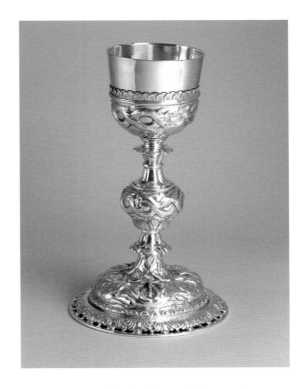

Fig. 93 Cardinal Howard's chalice, silver, parcel-gilt, *c.* 1700, Antwerp (St Dominic's Priory, London)

Sisters of Rouen note: 'The year of Our Lord 1737 Lady Brown of Kidington made us a noble present of ancient antiquity which had been found as her ladyship said in the ruins of an old abbey of Catholic

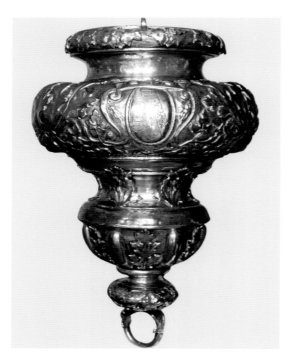

times. This year 1741 it was made into a reliquary to set upon the altar, Mr Hinde our confessor giving us a box of relics that had been given to James the 3rd.'

Whether the vessel was originally mounted as a reliquary or a secular cup is a matter of debate, but Sir Charles Browne was descended from Sir Anthony Browne, Viscount Mountague of Cowdray (1528–1592). He was one of the most powerful Catholics in England, treading a careful political path through successive reigns. In 1550, during Edward VI's reign, he was committed to the Fleet Prison for hearing Mass at Princess Mary's chapel, but in 1553, during the following reign, he became a commissioner of church goods in Sussex. He was one of the chief mourners at Mary I's funeral and acted as her executor. Still in favour under Elizabeth, he entertained the Queen at Cowdray in 1591 and served as her ambassador to Spain and Flanders. Sir Anthony owned several monastic properties in Surrey and Sussex, including Battle Abbey, so there may be truth in the family tradition voiced by Lady Browne that the reliquary had come from 'the ruins of an old abbey of Catholic times'.

The complex political and social world of leading Catholic families in seventeenth and eighteenth-century England can perhaps be best seen through another story, that of the Petre family of Essex. The extended Petre family is one of the best documented Catholic households in the country. In the late sixteenth century the composer William Byrd (1543–1623) settled near the Petre family home at Ingatestone and often attended Mass there. In 1607 he dedicated his second book of *Gradualia* to Lord

Petre of Whittle with the comment that since 'the contents have mostly proceeded from your house [and have been] plucked as it were from your gardens, [they are] most rightfully due to you as tithes'. Byrd occasionally stayed with the Petres at their house at West Thorndon and his famous settings of the Ordinary of the Mass were probably written in the first instance for the Petre establishment.

As was appropriate to their status, the family maintained high-ranking Continental Catholic connections. In 1669, Count Magalotti, who accompanied Grand Duke Cosimo III of Tuscany on his visit to England, visited the 4th Lord Petre at Thorndon. He noted that Petre lived in a style commensurate with his fortune of £10,000 per annum, a significant part of which would probably have been spent on his chapel. This was certainly the case with Queen Catherine, whose greatest financial burden, according to Magalotti, was the maintenance of her chapel in St James's Palace, which she attended on every feast day. This cost £8,000 *per annum* and included the community of Portuguese Franciscans set up entirely by her, with eleven priests, including Dominicans and Benedictines equal in number, as well as provisions for the Grand Almoner, four ordinary Almoners, and seven or eight other chaplains and clerics.

By the beginning of the eighteenth century the Petres were clearly a significant magnet for East Anglian Catholics and the 1706 record of Essex papists indicates that, in addition to members of the family itself, some twenty members of the Petre household were practising Catholics. The sacred

silver owned by the family at this date suggests a well-equipped chapel and included a silver-gilt incense boat (fig. 95) and a silvered brass sanctuary lamp (fig. 94) dating from the 1670s and '80s. The lamp bears the cipher MP for Mary Clifton, wife of the 6th Baron Petre, who retired to the English Benedictine convent in Ghent after her husband's death in 1707. The most spectacular Petre plate was yet to come, however. The 'best chalice' (fig. 89) and cruet set (fig. 96) were probably a special commission from the immigrant German goldsmith Charles Kandler, who came from Dresden and was working at the sign of the Mitre in St Martin's Lane from about 1725. Made for the sophisticated 8th Lord Petre, the chalice is ornamented on the foot, stem and bowl with pierced silver embellished with winged angels and the instruments of the Passion over a silver-gilt base. The plate was commissioned for use in the new chapel at Thorndon, which was designed by the

Fig. 96 Altar cruet and stand, silver, parcel-gilt, Charles Kandler, *c.* 1635, made for the 8th Baron Petre (Bishop of Brentwood, on loan to the Victoria and Albert Museum)

Fig. 97 Flower vase, Charles Kandler, *c.* 1730 (Arundel Castle)

Venetian architect Giacomo Leoni and built from 1733. Kandler's vessels augmented the existing family chapel silver listed in the 1731 inventory.

A contemporary manuscript manual entitled *RULES to be observed in the Chapple at ye Right Honble Robert James Ld Petre's At Thorndon in Essex MDCCXLI* indicates that this chalice and cruet set were only for use on exposition days, including the feasts of the Assumption, Candlemas and Corpus Christi, when devotion was shown to the reserved sacrament. On these occasions the best vestments and laced linen were worn. There were six silver candlesticks on the altar and two flower pots on the urn stands. Lord Petre was one of the leading horticulturalists in the country: he produced the first camellia to flower in England and these vases may have supported specimens of white lilac or camellia grown in his garden.

The detailed instructions in the Thorndon

manual give a clear sense of the magnificence of religious observation in the Petre household. For example, 'On Maundy Thursday the best Chalice must be set in the Canopy with a crown upon it with the best book and cards but not the best Crewets. Two candles upon the altar, the full number is not to be lighted until after the communion. Incense is used when the Venerable is put in the Canopy. After Mass the marble steps must be covered with black & the curtains let down. Six small silver candlesticks to be placed on the marble steps, 3 on each side. At Tenebrae these must be set upon the altar and put out as the office shows. Total number of candles 14 on the altar; 6 in the silver candlesticks; two in the great stands, two in the Gallery.'

These meticulous instructions demonstrate that, despite the endurance of deeply held prejudices against the Catholic rite, its observance continued to flourish in England during the eighteenth century. Such elaborate liturgical choreography called for sophisticated plate and the leading supplier of recusant silver between the two Jacobite rebellions of 1715 and 1745 was Charles Kandler.

The Petres were just one of a number of aristocratic Catholic families, all connected with one other, whose patronage Kandler enjoyed. He was probably recommended to Lord Petre by his kinsman, Edward, 9th Duke of Norfolk, to whose brother, the 8th Duke, Kandler had already supplied a splendid gilt-brass tabernacle at Arundel Castle. This was designed by the architect James Gibbs and is probably the earliest surviving tabernacle made in England since the Reformation. Gibbs may well also

have designed the Kandler flower vases (fig. 97) and
holy water pail and sprinkler (fig. 98)at Arundel.

In addition to the Norfolks and the Petres,
Kandler's Catholic patrons included Littleton Poyntz
Meynell (who was closely linked to Henry Jerning-
ham of Costessey), the Duke of Cleveland, Lord
Clifford of Chudleigh and Lord Arundell. Catholic
silver marked by Charles Kandler is still in use in the
Clifford family chapel at Ugbrooke in Devon and
in the Arundell chapel at Wardour Castle. Kandler's
ciborium at Ugbrooke is fully marked for 1732, while
at Wardour there is a chalice of about 1730 and a set
of six altar candlesticks of 1733. Charles Kandler is
known to have returned by 1735 to Dresden, where
he assisted his elder brother, the chief modeller for
the Meissen porcelain factory. His relative Frederick
Kandler took over commissions for Catholic silver
in London, supplying the 9th Duke of Norfolk
the 8th Lord Arundell and Thomas Weld, who had
just built a free-standing chapel at Lulworth, dis-
guised as a mausoleum, to the designs of Catholic
architect John Tasker.

Robert, 8th Baron Petre died of smallpox
in 1742. His death was widely mourned and inspired
Jonathan Tyers, the wealthy proprietor of London's
famous pleasure gardens at Vauxhall, to create
a memorial garden dominated by the Temple of
Death with a monument to Lord Petre by Roubiliac.
He was succeeded by his son, Robert, who married
a niece of the 9th Duke of Norfolk and in 1764 com-
missioned a new house and chapel at Thorndon
from the architect James Paine. The chapel was dedi-
cated in 1770 and remained in use through the nine-

Fig. 98 Holy water bucket and sprinkler, Charles Kandler, *c.* 1730
(Arundel Castle)

teenth century. James Paine also designed Lord
Petre's town house in Mayfair, which incorporated
a chapel and accommodation for the chaplain dis-
creetly on the bedroom floor. The house was
destroyed during the anti-Catholic Gordon Riots
in 1780, when the mob looted, burned and ruined
Catholic chapels including the Sardinian Embassy
Chapel in Lincoln's Inn Fields and various private
Catholic homes. As the head of a leading Catholic
family, Lord Petre was a conspicuous target. But the
tide was turning. In 1791 the first Catholic Relief Act
legalized the building of Catholic places of worship
and in 1829 the Catholic Emancipation Act finally
allowed Roman Catholics to play a full and equal
part in public life. Catholics in England could now
openly acknowledge their heritage; silver for use in
the Catholic rite could be freely commissioned and
hallmarked without concern for the consequences.
Recusancy and concealment were a thing of the past.

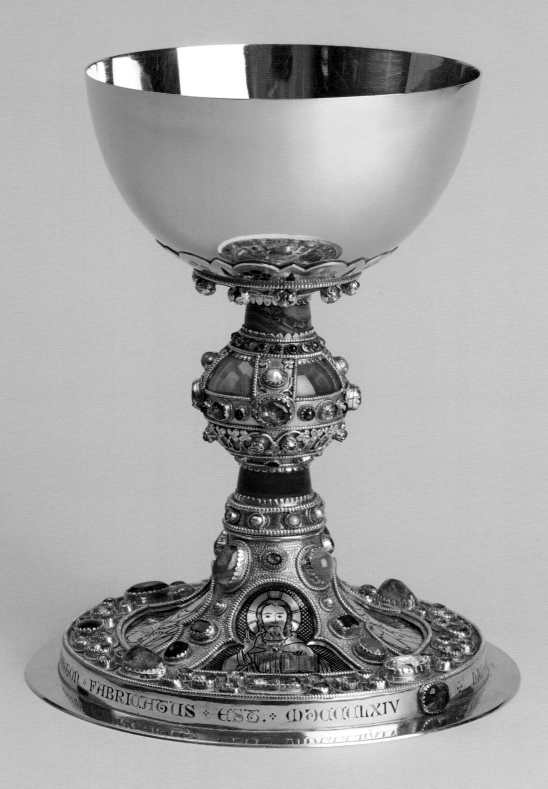

Fig. 99 Chalice, silver-gilt, niello, precious and semi-precious stones, John Hardman & Co., Birmingham (designed by William Burges), 1863 (St Michael and All Angels, Brighton)

The Victorian Resurgence

Jim Cheshire

With the benefit of hindsight we can see that Christian worship in Britain was at a turning point at the start of the Victorian period. Although the evangelical revival had injected a new earnestness and vigour to sections of the established Church, anticlericalism was widespread and the financial irregularities of patronage and pluralism added to the impression that the Anglican priesthood was just another section of the privileged ruling class. The response, which took the form of a 'High Church' movement, had a profound effect on the identity of the Church. Both the way worship was conducted and the objects and buildings associated with Anglican worship were dramatically transformed in parishes across the country. In the High Church revival the Holy Eucharist became the focal point of the service and this created the ideal conditions for a renewal of interest in ecclesiastical plate.

William Butterfield's ornate chalice (fig. 101) designed for his famous church, All Saints Margaret Street (fig. 100), is a useful starting-point for a discussion of Victorian church plate. The breadth and relative shallowness of the bowl signal a debt to

Fig. 100 View of East end of All Saints Margaret Street, London

Fig. 101 Chalice, silver-gilt, precious and semi-precious stones, John Keith (designed by William Butterfield), 1854 (All Saints Margaret Street, London)

medieval precedents and the colour and extra-ordinary richness created by the encrustation of dia-monds, pearls, carbuncles and turquoises is indicative of the importance of the Eucharist to the High Church party within the Church of England. The richness of the chalice is echoed by the church for which it was designed: All Saints came to epitomize both the High Victorian Gothic style and an elaborate form of worship that placed great emphasis on the mystery of the sacraments. It is symptomatic of a huge rise in church building apparent across the country; in the peak decade, the 1860s, over one thousand new or rebuilt Anglican churches were consecrated, all needing new interiors, furnishings and sacred vessels, which created work for a genera-

tion of architects and designers. The scale of Victorian church building was far greater than this, however, as a similar surge in building activity took place across the denominations. For Roman Catholics and Non-conformists this was partly a response to the repeal of legislation in the late 1820s that had restricted their civil and religious freedoms. These groups were now free to practise their religion as they wished, and the physical presence of their new buildings was a material reminder that the Church of England now had to compete harder for the allegiance of the population. The established Church was stimulated towards internal reform and one development in particular, the Oxford Movement, had profound implications for architecture and design. This High Church revival was initiated by a theological trend that emerged at Oxford University in the 1830s and that would eventually inspire many of William Butterfield's important patrons.

The leaders of the 'Oxford Movement' set out to re-assert the spiritual authority of the Church of England. They started to reassess the nature of the Anglican Church by stressing its status as the Reformed but, in the words of the Nicene Creed, still 'catholic' and 'apostolic' church. A central doctrine known as the 'Apostolic Succession' emphasized the status of the bishops, and by implication priests, by arguing that their authority was derived, through ordination, from the Apostles themselves. This was in part a reaction against what they perceived as state interference in ecclesiastical matters. High churchmen provoked a series of disputes during the Victorian period that questioned whether a secular

government had the authority to legislate on issues which they considered sacred. This new understanding of clerical authority was reflected in an increased emphasis on the sacramental rites performed by Anglican priests. In a move away from the evangelical emphasis on the sermon and the Bible, followers of the Oxford Movement concentrated both liturgically and aesthetically on the sacraments, particularly the Holy Eucharist. Communion was celebrated more frequently and architects were encouraged to make the altar the architectural focus of the building. In this context it is clear that the chalice, flagon and paten took on a new significance. With the mystery of sacramental transformation at the heart of the church service, new demands were made of ecclesiastical interiors and the services performed in them. Intense decoration, colour and ornament were combined with elaborate choral singing and, in some churches, the smell of incense: the Anglican service became a richer sensory experience. All Saints Margaret Street became a centre for this form of worship, in fact the vicar became so extreme in his interpretation of the liturgy that many of the key patrons of the church later dissociated themselves from the building. In this context the opulence of Butterfield's chalice becomes less surprising, especially in the light of the knowledge that the gems set into it were taken from jewellery donated for this purpose by female members of the congregation. While this is a testament to the piety of the donors it also underlines the fact that congregations in this type of church were often wealthy and fashionable.

Fig. 102 Mitre, silver-gilt and jewels, designed by A.W.N. Pugin, 1848 (Westminster Cathedral)

The Oxford Movement would have had a much less pronounced effect on the design and material culture of Victorian Britain if its ideas had not been pushed with considerable enthusiasm by the ecclesiological movement. Originating in an undergraduate society, the Cambridge Camden Society, the

Fig. 103 Page from *Instrumenta Ecclesiastica*, 1856 (National Art Library, Victoria and Albert Museum)

ecclesiological movement translated the ideas of the Oxford theologians into an agenda for the 'correct' design of churches. The ideal ecclesiological church had to be Gothic, have a large chancel – to place emphasis on the altar – and be richly decorated. They encouraged the use of encaustic tiles, brass altar rails, stained glass, rich textiles for vestments and altar frontals and church plate in a medieval style. The ideas of the Cambridge Camden Society were circulated through their highly opinionated journal *The Ecclesiologist* and a series of related publications that gave advice about sources for design and how to go about church restoration. In 1842 a letter signed 'W.B.', whose author described himself

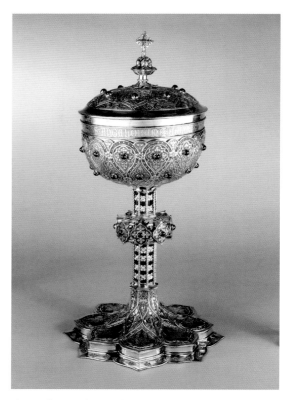

Fig. 104 Ciborium, silver, parcel-gilt, enamel and semi-precious stones, John Hardman & Co., Birmingham (designed by A.W.N. Pugin), 1894 (St Mary's Church, Clapham, London)

as an architect who 'hoped to become a member of the Camden Society', raised an issue about the relative merits of altar rails and chancel screens. Later in the same year another letter, this time more openly signed 'W. Butterfield', complained of the poor quality of contemporary church plate. The result of this was a collection of designs developed in consultation with the Cambridge Camden Society and entitled *Instrumenta ecclesiastica*. This first appeared in 1847, with a second volume published in 1856. An image from the second volume illustrates communion plate designed by Butterfield and made by John Keith for the Great Exhibition of 1851 (fig. 103). The similarity between these objects and much of the church plate illustrated in this chapter show that a fairly consistent vocabulary of shapes and styles had already emerged by the early 1850s.

Although the Cambridge Camden Society was happy to take the credit for reforming Anglican ecclesiastical design, the fact is that their programme was heavily indebted to the brilliant young Roman Catholic architect A.W.N. Pugin. His impact as a designer was profound but he arguably exerted an even wider influence through his written works. Two of the most important, *Contrasts* and *The True Principles of Pointed or Christian Architecture*, were published in 1836 and 1841, at the beginning of the church building boom. These books put forward the argument that Gothic was not just aesthetically but also morally superior to classical styles. Pugin insisted that since classical architecture had emerged from a pre-Christian culture it was essentially pagan; Gothic, on the other hand, was a product of the

Middle Ages and so was fundamentally Christian. What is more, he argued that the truth of this could be proved through analysis of each of these styles. Classical architecture was dishonest because it concealed its structure while Gothic was honest because its structural elements were revealed for all to see. Gothic architecture and design used materials in harmony with their essential properties while classically derived styles exhibited no understanding of their constituent materials. In relation to metalwork Pugin urged a return to the traditional techniques of piercing, chasing, engraving and enamelling, while he condemned more industrial techniques such as die-stamping as a symptom of silverwork becoming a 'mere trade'. *Instrumenta ecclesiastica* echoed this approach when describing the appropriate treatment of a chalice: 'Every part is wrought, casting not being allowable'. This is typical of the ecclesiological movement – they adopted Pugin's ideas and translated them into an Anglican context, ironically making Pugin more influential in the long run on Anglican than on Roman Catholic design.

Pugin's attitude to metalwork can be usefully observed in a wonderfully ornate ciborium made late in his working life (fig. 104). This was a very expensive object: John Hardman's daybook records its price as £75. It is a testament to Pugin's skill that he was able to combine so many expensive materials and include so much ornament without making the object overpowering or gaudy. The ciborium is typical of Pugin's approach to decoration and the foot is very close to an image in *True Principles* illustrating appropriate techniques.

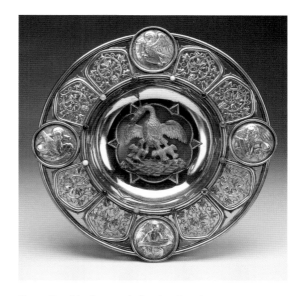

Fig. 105 Altar dish, silver, parcel-gilt and semi-precious stones, 1894 (Great Hockham, Norwich)

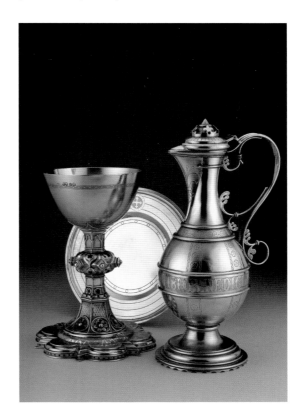

Fig. 106 Communion service, silver and enamel, John Keith (designed by William Butterfield), 1856 (Balliol College, Oxford)

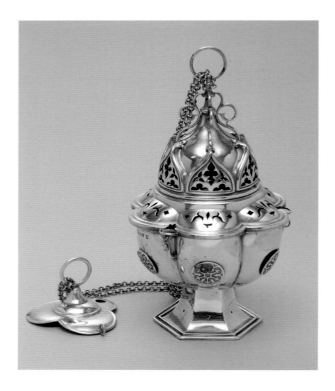

Fig. 107 Censer, silver, John Hardman & Co., Birmingham
(designed by A.W.N. Pugin), *c.* 1838 (St Mary College, Oscott)

Much of Pugin's motivation as a designer came from his religious conviction and drive to revive the glories of the English medieval church. His interest in metalwork dates to the start of his career but the first documented pieces associated with him are the cruet set and censer made for St Mary's College Oscott, where he had been appointed Professor of Ecclesiastical Antiquities in 1844 (fig. 107). The chapel at Oscott was consecrated in May 1838, in a service which Pugin, who found the whole occasion emotionally overwhelming, later described as 'decidedly the most splendid function that England has seen since the Loss of the antient faith'.

While the basic forms of High Victorian Gothic church plate were somewhat limited, accomplished designers still found room for variation. A wonderful example is William Burges's chalice from the church of St Michael and All Angels in Brighton (fig. 108) and a comparison to Butterfield's Margaret Street chalice is instructive (fig. 101). Butterfield's, perhaps inspired by a fourteenth-century Sienese chalice, is dominated by the stones set across its surface and, while the gems certainly add to the density and richness of ornament, they detract from the purity of the form, especially when compared to his chalice from Balliol College, Oxford (fig. 106). Burges's chalice, on the other hand, skilfully combines purity of form with density of decoration. Unlike Butterfield's, all its parts are of circular section but the design achieves clarity by clearly separating the different decorative techniques.

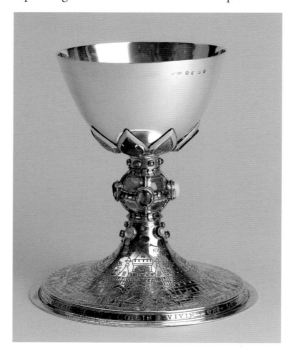

Fig. 108 Chalice, silver, parcel-gilt, precious and semi-precious stones, John Hardman & Co., Birmingham (designed by William Burges), 1862 (St Michael and All Angels, Brighton)

From the plain bowl the leaf-shaped calyx intro-
duces the central section, dominated by the crystal
knop. This in turn leads to the more linear character
of the engraving on the foot. The colour scheme
subtly combines silver and silver-gilt and Burges's
own notes on this design show that he specified the
exact type of semi-precious stone to be used in each
instance. This chalice shows that, at its best, Victor-
ian Gothic produced objects of stunning quality that
did far more than just imitate medieval styles.

Religious zeal, population growth and the great
wealth generated in the mid-Victorian period
helped to drive the church building boom in the
1850s and '60s. This ubiquitous programme of
building and refurbishment created a market
for an entirely new type of business – the church

Fig. 110 Flagon, silver, parcel-gilt, enamel, Birmingam, 1862
maker's mark S&Co. (Whixley Church, on loan to Ripon Cathedral)

furnisher. Just as secular drapers and furniture
sellers were starting to merge into what we now
think of as department stores, certain businesses
developed the capacity to furnish entire churches,
selling wooden and metal furniture, textiles, lighting
equipment, vestments, stained glass and commun-
ion plate. Ecclesiologists were hostile to what they
described as 'mere manufacture' but despite this the
forms developed by their approved designers came
to dominate commercial church plate design for the
rest of the century, a situation reinforced by the
publication of trade catalogues by such as John
Hardman & Co. (fig. 109). This was quite simply
because many of the manufacturers had worked at

Fig. 109 Page from Hardman & Co.'s 1875 catalogue
of 'chalices and patens'
(National Art Library, Victoria and Albert Museum)

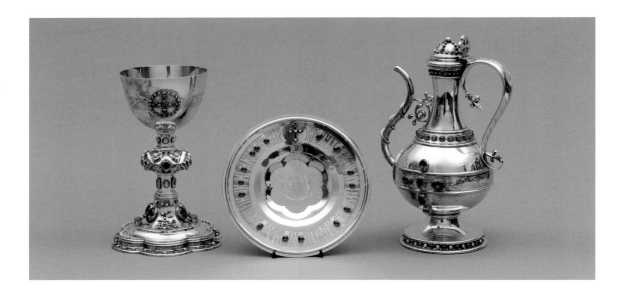

some stage with the leading architects, for example John Keith with Butterfield and Hardman with Pugin. Manufacturers made the most of these associations, Hardman's catalogue of about 1855 stating 'Messrs. Hardman & Co. are the only Artists engaged in the revival of ancient Church Ornaments and Metal Work, who have been supplied with Drawings, Models, and Authorities, by the late A.W. Pugin, Esq.'. Other manufacturers who could not claim such an association made more generic comments about being advised by eminent architects. The church furnishers also exhibited enthusiastically in the series of international exhibitions inaugurated by the Great Exhibition of 1851, proudly exhibiting their awards at the start of their catalogues.

By the 1860s a new generation of architects and designers had started to react against what they perceived as the uniformity and commercialization of church furnishers and the strident character of High Victorian Gothic. The idea of the uniform church

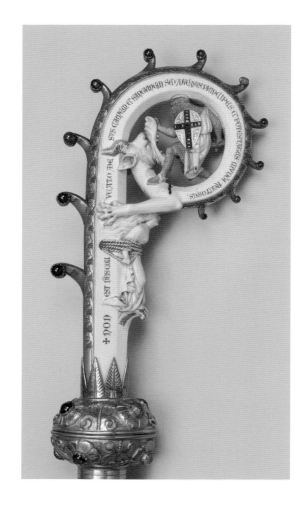

interior designed by a single architect began to be challenged by what eventually became known as the Arts and Crafts movement, which championed a more individual approach to the design and making of objects. At the same time the High Church revival, which had developed from the Oxford Movement into ecclesiology, was becoming a more open and militant liturgical movement that became known as ritualism. One figure heavily involved in both movements was the architect J.D. Sedding, whose processional cross of 1889 (fig. 113) is a good example of the direction that late Victorian ecclesiastical metalwork had started to take. The cross is beautifully designed and made but its materials are relatively inexpensive: a layer of electroplated silver covers a wooden core and the figures are bronze. This approach can be related to the preference for semi-precious stones and enamels rather than diamonds and gold that characterizes the jewellery of the Arts and Crafts movement. The artistic credentials of the cross are not in doubt, as the figure of Christ was designed by Onslow Ford, one of the most prominent British sculptors of the following decades. Only the fleurs-de-lys on the cross make any distinct reference to medieval styles; the naturalism of the ornament points strongly towards the Arts and Crafts style, a relationship confirmed by its inclusion in the Arts and Crafts Exhibition of 1889.

Sedding died early, just two years after the cross was made, and his outstanding commissions were taken over by his gifted pupil Henry Wilson, whose manner pushed Sedding's individuality far further and whose work cannot be described in any mean-

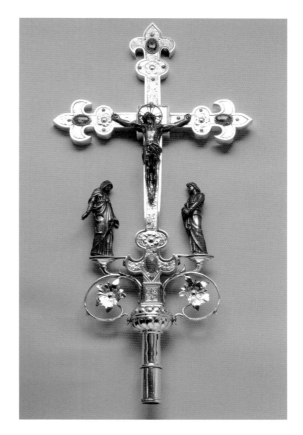

ingful sense as Victorian. The importance of Gothic as a style was already fading but the theories developed during the Victorian Gothic Revival and their articulation during the Arts and Crafts Movement had a lasting influence on European design.

Facing page, top: Fig. 111 Communion service, silver-gilt and precious stones, Joht Keith, 1856 (Bojne Hill, Berks.)

Facing page, below: Fig. 112 Crozier, silver-gilt, ivory and enamel, Jes Barkentin (designed by William Burges), 1865 (Canterbury Cathedral)

Above: Fig. 113 Processional cross, electroplated silver with bronze figures, Longden & Co. (designed by J.D. Sedding), 1889 (St Matthew's, Sheffield)

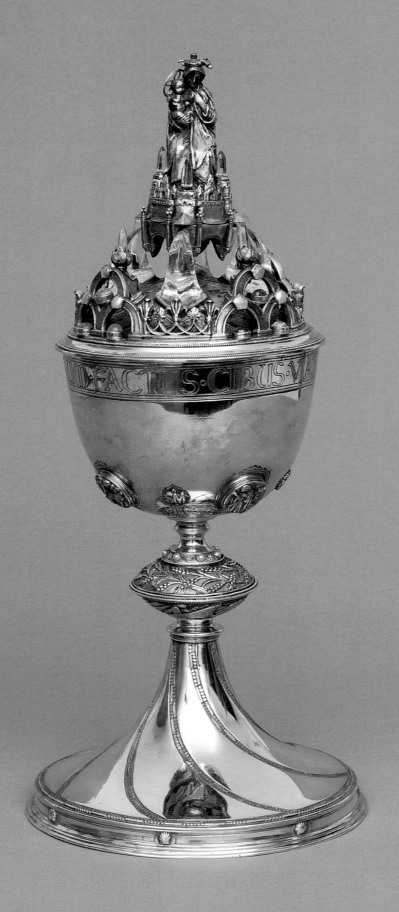

Fig. 114 Ciborium, silver-gilt, enamel and rock crystal, J.H.M. Bonner, *c.* 1910 (St Margaret's Church, Oxford)

The Early Twentieth Century

Eric Turner

'A word has now to be said on ecclesiastical silversmithing …. Silverwork for devotional purposes … must always have a place apart. It expresses the human mind in its austerer, its more spiritual moments, it implies Ruskin's Lamp of Sacrifice. This sacrifice must be dual, it must show not only the devotion of him who dedicates a piece of silver to a higher service, but also the devotion of the piece so dedicated.'

These words were written by Charles Ashbee (1863–1942) in his book *Modern English Silverwork,* written in 1909, shortly after his Guild of Handicraft had suffered irretrievable financial collapse. The guild had lasted barely twenty years and had not been a commercial success. Some of its early attempts to design and produce silverware were crude and amateurish and its collapse was partly due to Ashbee's unbusinesslike insistence on excluding from his workforce anyone who had previous trade experience, for fear of corrupting the others with commercial values. Yet Ashbee remains a true pioneer of modern design and the starting point

of any discussion of English twentieth-century silver, his importance lying in the fact that, virtually single-handedly, he revolutionized its culture.

Ashbee came from a middle class, if not entirely conventional background.* His father was a successful merchant who expected his son to join him in the business. But Ashbee had other ideas. His secondary education at Wellington College, one of the newest and most expensive Victorian public schools, did little to fire his imagination. His subsequent undergraduate career at King's College, Cambridge, however, did. Stimulated by the intellectual company of fellow undergraduates such as Goldsworthy Lowes Dickinson and Roger Fry, teachers such as J.R. Seeley, the Regius Professor of Modern History, and his meeting through his Cambridge contacts with the utopian socialist Edward Carpenter, Ashbee formed the bedrock of the intellectual values that were to remain with him for the rest of his life. One of the most profound influences on his thinking was the writings of John Ruskin. From Ruskin he learnt to see art, architecture and the decorative arts in an integrated relationship and as a reflection on the

*His father, H.S. Ashbee, was a well-known bibliophile and collector of erotica who wrote under the pseudonym Pisanus Fraxi.

social conditions in which they were made. Ashbee's philosophy, which came to be shared by other members of the Arts and Crafts movement, was partly predicated on the romantic if historically naïve notion of the medieval period as a golden age before the days of industrial production. The medieval goldsmith was not merely a skilled engineer but an artist – the inventor as well as the maker.

Through the Guild of Handicraft Ashbee sought to reposition the silversmith at the very heart of artistic production. More than this, he re-evaluated the nature of the material itself. Under his direction, silver developed a new aesthetic language whose grammar was simple, flowing geometric forms, enhanced by elegantly curved wirework; the occasional area of richly coloured enamel was offset by a single semi-precious stone in a plain setting and the surface of the silver always softly planished. His designs, epitomized by two chalices of 1903 and 1904 made for Upton upon Severn and Broad Campden (fig. 115), downplayed the preciousness of the metal; instead he gave it a quiet, formal nobility which was revolutionary.

Ashbee's friend and contemporary Henry Wilson (1864–1934) was another distinguished silversmith of the Arts and Crafts movement. Like Ashbee, he initially trained as an architect, first in the office of John Oldrid Scott, moving to that of John Belcher R.A. in 1885 and subsequently to J.D. Sedding's office as his chief assistant, taking charge of the practice on Sedding's death in 1891. At the same time Wilson developed a keen interest in metalwork which gradually began to dominate

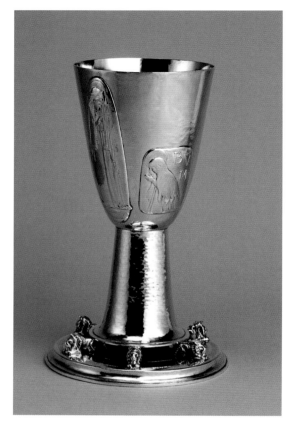

Fig. 115 Chalice, silver, Guild of Handicraft, 1903
(given in 1911 by Janet, wife of C.R. Ashbee) (Broad Campden, Gloucs.)

his work and led him to set up a workshop for silver and jewellery in Kent in 1895. In order to extend his range, he also took up the study of sculpture.

Wilson's output, consistently distinguished, was relatively small owing to his many other commitments. From 1896 he taught metalwork under W.R. Lethaby and George Frampton at the Central School of Arts and Crafts and in 1901 followed Lethaby to the Royal College of Art. A year later he published his manual *Silverwork and Jewellery,* which rapidly became a standard handbook for all silversmithing and jewellery students and is still widely regarded as the best practical manual on the subject.

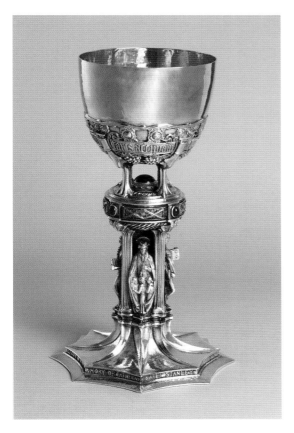

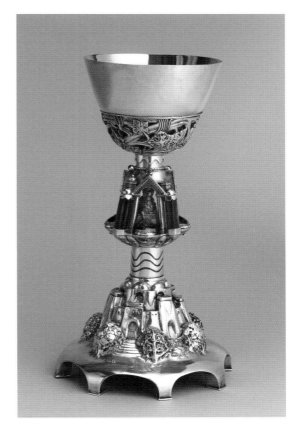

Fig. 116 Chalice, silver, parcel-gilt, enamel and precious stones
Omar Ramsden, 1914 (Whitelands College, Roehampton)

Fig. 117 The Tinling Chalice, silver, parcel-gilt, enamel, Henry Wilson
assisted by S. Wiseman and H.G. Murphy, *c.* 1900 (Gloucester Cathedral)

Wilson's metalwork designs have a rich, idio-syncratic style, partly derived from his own observations of nature and certainly influenced by Lethaby's interest in Byzantine architecture and design. Two of his most splendid pieces of ecclesiastical metalwork are the chalices made for St Bartholomew's Church, Brighton, and Gloucester Cathedral in about 1898 and 1902. Both are parcel-gilt, the first decorated with ivory and enamel and the second, the Tinling Chalice, designed as a sort of architectural conceit with enamel, niello and semi-precious stones (fig. 117). The latter was particularly well received; it was lent to an exhibition of Christian art in Dusseldorf in 1909 and again to Paris in 1914.

Another prominent member of the English Arts and Crafts Movement was Harold Stabler (1872–1945). He started his career as an apprentice cabinetmaker to Arthur Simpson, a member of the Keswick School of Industrial Art founded in Cumberland by Canon and Mrs Rawnsley in 1884. He studied cabinetmaking, stone masonry and metalwork at the Kendal Art School and subsequently held a number of teaching posts at Keswick, Liverpool and the Sir John Cass Technical Institute in London, remaining Head of the Art School there from 1907 until 1937.

With such a background it comes as no surprise that Stabler had wide-ranging interests. He was a co-founder of the Carter, Stabler and Adams Pottery as well as being associated with Poole Pottery which supplied tiles for London Underground such as can still be seen at St Paul's station and elsewhere. He was also a founder member of the Design and Industries Association, which was established in 1915 to promote modern design. But nowadays he is best remembered for his silverwork, exerting a strong influence on English silversmithing in the first half of the twentieth century. One of his most impressive works, the mace made for Westminster Cathedral in 1911 (fig. 118), is designed in the form of a square, domed Byzantine shrine and suggests the influence of Henry Wilson. Stabler was evidently very proud of the mace for, exceptionally in his work, it is inscribed, beneath the head: *HAROLDUS STABLER ME FECIT LONDON MCMXI.*

If Stabler hardly ever signed his work, Omar Ramsden (1873–1939) almost always did. Ramsden's work was deeply rooted in the English Arts and Crafts movement, but in many ways he was the antithesis of Ashbee. Along with his long-term partner Alwyn Carr (1872–1940), he was trained at the Sheffield School of Art, where the curriculum concentrated on drawing, geometry and perspective and an emulative study of historical ornament. What certainly was not included in his formal education was any training in the silversmithing craft. His only practical grounding was through a short-lived apprenticeship in his father's manufacturing business, and throughout his career he relied on his

assistants to achieve the consistently high standards of craftsmanship for which his firm became justly famous.

Unlike Ashbee, Ramsden was no intellectual, but he was an astute businessman and consummate self-publicist. Towards the end of his career he claimed in an interview: 'I got out of Sheffield as soon as I possibly could because I realised that there was no opening for a craftsman there …. Sheffield is a city of manufacturers.' This was a faint and self-serving echo of Ashbee's observations on his first visit to Sheffield. Ashbee had been candidly impressed by what he saw as the raw beauty of a steel foundry but dismissive of the cutlery workshop with its mass-production methods that converted the steel into cheap, characterless, utilitarian goods.

By the 1920s Ramsden was running one of the biggest silversmithing studios in London and had placed the business on a very solid financial footing. His success lay in his ability to synthesize various aesthetic strands in the Arts and Crafts movement and develop a recognizable and distinctive style. In their interpretation of medieval precedents his workshop's designs were far more literal than Ashbee's ever were. But other elements were evident from time to time and his work occasionally displayed the influence of European Art Nouveau.

Ramsden was one of the leading early twentieth-century suppliers of church plate and produced a wide range of specially commissioned chalices, ciboria, monstrances and croziers drawing on both the Gothic and Romanesque styles. The silver-gilt and jewel-set chalice made for Westminster Abbey

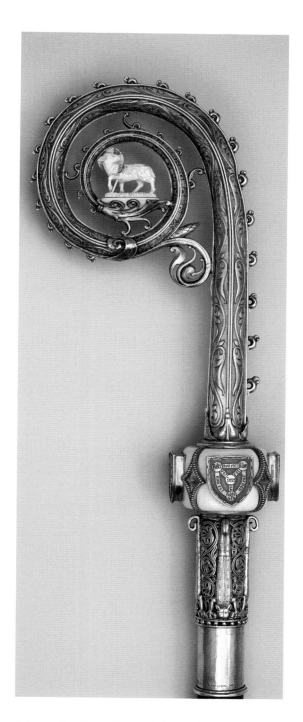

Facing page: Fig. 118 Mace, silver, parcel-gilt, enamel and rock crystal, Harold Stabler, 1911 (Westminster Cathedral)

Above: Fig. 119 Crozier, silver-gilt, enamel and ivory Omar Ramsden, 1927 (Guildford Cathedral)

Figs. 120, 121 Alms dish, silver-gilt, Comyns & Co., 1938; altar cross, silver-gilt and rock crystal (both designed by Leslie Durbin) (Guildford Cathedral)

is Romanesque and the 1927 crozier for Guildford Cathedral Gothic (fig. 119). The magnificent monstrance which he and Carr designed and executed for Westminster Cathedral in 1907 (figs. 122, 123) was, according to them, a free interpretation of Spanish medieval goldsmiths' work. It can be considered as one of their masterpieces.

The most talented of Ramsden's apprentices was Leslie Durbin (1913–2005). Durbin came from an underprivileged background. At the age of four his father died as a result of the influenza epidemic and his mother took in dressmaking to support herself and her young family. It must have been a relief to her when, at the age of thirteen, Leslie won a London County Council Trade Scholarship and entered the silversmithing class at the Central School. Three years later he was taken on as Ramsden's apprentice. To Durbin's dismay, he discovered on reading his articles that he was to be employed as a 'chaser, engraver and decorator of precious metals' whereas he had hoped to receive a more general training in silversmithing. To rectify this, he enrolled in evening classes at the Central School. His apprenticeship having expired, he stayed with Ramsden for a further two years but in 1937 he won a Goldsmiths' Company scholarship to study full time and returned to the Central School to be taught under one of the most able silversmiths of his day, H.G. Murphy. Durbin later recalled this as one of the happiest periods of his life.

Durbin's career as one of the most important makers of church silver of his generation began while he was still at the Central School, when he won

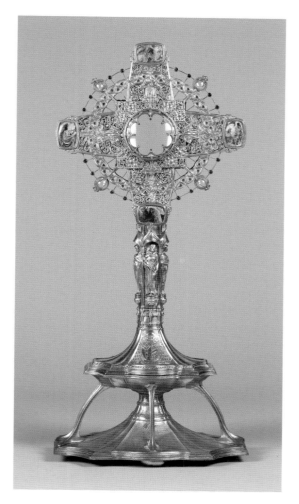

Fig. 122 Omar Ramsden, Design for the Westminster Monstrance, pencil and watercolour (Westminster Cathedral)

Fig. 123 Monstrance, silver-gilt, glass, rock-crystal and gemstones, Omar Ramsden and Alwyn Carr, 1906 (Westminster Cathedral)

a competition in 1938 to design altar plate for Guildford Cathedral, then being built to the design of Sir Edward Maufe. The Goldsmiths' Company arranged the competition with a £2,500 grant under the supervision of the architect and the bishop. Apart from the altar cross (fig. 123) and candlesticks, Durbin also made plate for the Children's Chapel and the Chapel of Chivalry. The following year, the Company decided to show the complete set as the focal point in the 1938 exhibition of modern silverwork at Goldsmiths' Hall. In order to get it finished on time, Durbin had to employ staff and fellow students at his own expense. Ecclesiastical commissions were to be a regular and steady part of his income when he set up his own workshop in Camden Town after the war. But this aspect of his work is a subject for the next chapter.

Fig. 124 Altar cross, silver, David Mellor, 1970,
the corpus modelled by Elizabeth Frink
(Lady Chapel, Liverpool Metropolitan Cathedral)

Church Plate since the Second World War

Rosemary Ransome Wallis

The new cathedral at Coventry, begun in 1956 and completed in 1962, is one of the few post-war buildings to meet with widespread popular approval. A single statement of faith, it rises beside the ruins of the old cathedral, devastated by enemy action on the night of 14 November 1940. The evocative ruins of the medieval cathedral remain today as consecrated ground, with the east end marked by a simple cross of charred timbers.

Sir Basil Spence, architect of the new Cathedral Church of St Michael, wanted his design to stand for the Triumph of the Resurrection. Standing at right angles to the old, the majestic Spence porch links the two buildings, with Epstein's striking sculpture of *St Michael defeating the Devil* flanking the entrance steps.

The overwhelming impression of the interior is of height, light and colour. Famous works of art in the cathedral include the huge Graham Sutherland *Christ in Glory* tapestry behind the altar and the magnificent baptistery window by John Piper. But Spence was also keen to commission work from younger and less well known artists. One was

Geoffrey Clarke, who made the massive silver-gilt cross for the high altar (fig. 125). Designed as an abstract interpretation of the charred cross in the ruins, it has a cross of nails taken from the timbers as its central feature. The cross was donated by the Goldsmiths' Company in 1958.

In the 1950s the company developed a policy of actively encouraging the younger generation of designers through its own growing collection of contemporary silver. A measure of the success of this policy was the inspiration it gave to outside patrons commissioning new work themselves. Among the silversmiths commissioned to make church silver for the collection, for example, were Geoffrey Clarke and Louis Osman. Clarke made a large altar cross in cast oxidized silver, his design inviting the spectator to contemplate the divine through pure form (fig. 126); Osman's response was a monumental and heavy silver alms dish, cast with a hand-forged edge and with carved and gilded letters of alpha and omega in the centre (fig. 127).

Osman remained a key figure throughout the 1960s and '70s, although it is fair to say that he stood

Fig. 125 Altar cross, silver-gilt, Geoffrey Clarke, 1958
(Coventry Cathedral)

Fig. 126 Altar cross, silver, Geoffrey Clarke, 1958
(Goldsmiths' Company)

outside the mainstream of modernist design. For him creativity required emotional involvement and restless energy. His highly personal approach is seen in three extraordinary altar crosses from the 1960s that he created for Exeter and Ely Cathedrals and for King's College, London. The first, for Exeter Cathedral's St Gabriel Chapel, has a narrow cross of silver resting on a steel base with a central abstract enamel by Marit Aschan and is conceived as a quiet reminder of death and resurrection. The second, for

Ely, made in partnership with Graham Sutherland, symbolizes reincarnation: the massive silver cross has a gold cross within and is decorated with niello. Its stark form polarized opinion. Terence Mullaly described it as a 'heartening indication of the more intelligent interest in the arts being shown by the churches'; others were less flattering, and the cathedral authorities eventually decided it was inappropriate and sold it. It is now in the Dallas Museum of Art. The last of these crosses has a glory modelled as

a sprung mantrap, a symbol of Christ preventing evil from trapping mankind in death. Made in 1967, it hangs in King's College Chapel to this day.

Another major creator of church plate for the Goldsmiths' Company in the late 1950s was Gerald Benney. In the same year that he made a startlingly original chalice for the collection (fig. 128) he also undertook a silver altar set for Bishop Otter College in Chichester which was widely praised for its simple modernity. Benney's initial training had been under Dunstan Pruden, a Roman Catholic silversmith who had worked in Eric Gill's semi-religious community of craftsmen at Ditchling. Pruden's distinctive approach to silver – his sensitivity to the metal, his interest in Christian symbolism and his personal integrity (fig. 129) – has exercised a powerful influence on Benney throughout his career.

Benney was a graduate of the Royal College of Art, as were several other leading figures from this period, including Robert Welch and Eric Clements. Welch, who studied under Professor R.Y. Goodden, had a most important ecclesiastical patron, Canon Cyril Davis of St Mary's, Swansea, who commissioned an altar cross and candlesticks as a memorial to his parents and presented them to the newly rebuilt church in 1958. Davis later placed further commissions with Welch. Clements was a hugely productive silversmith who undertook over seventy major commissions for civic, institutional and church patrons during the 1950s. His 1958 chalice and paten for Holy Trinity, Nottingham, and the sanctuary lamp of the same year for All Hallows,

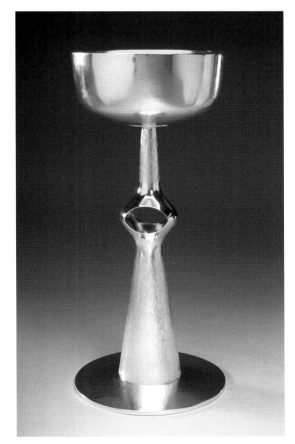

Fig. 127 Alpha and omega dish, silver, parcel-gilt, Louis Osman (Goldsmiths' Company)

Fig. 128 Chalice, silver, parcel-gilt, Gerald Benney, 1957 (Goldsmiths' Company)

Fig. 129 Chalice, gold, Dunstan Pruden, 1959, made from
the gold of 300 wedding rings given for the purpose
(Liverpool Metropolitan Cathedral)

Fig. 130 Processional staff, silver, parcel-gilt, Leslie Durbin, 1960
(Gloucester Cathedral)

Bosham, in Sussex are typical examples of his simple
linear style and sensitivity to form.

A star that was already risen was Leslie Durbin.
Durbin's reputation had already been established
before the war with commissions such as his well-
publicized 1938 altar plate for Guildford Cathedral.
Among his many striking post-war church commis-
sions, characterized by their fine balance of tradition

and modernity, is the staff given to Gloucester
Cathedral in 1960 by Lady Apsley in memory of her
husband (fig. 130). This is powerfully modelled with
a cast finial of St Michael, his sword held high, strik-
ing down the hydra representing Satan.

One of the most successful names in the field of
silversmithing and industrial design at this time was
David Mellor, another Royal College graduate, who

was born and worked in Sheffield. In 1963 Mellor made a magnificent large nave altar cross for South-well Minster, constructed out of bands of silver meeting to make a central cross. But he also had the opportunity of designing silver for contemporary ecclesiastical settings. For Frederick Gibberd's radi-cally original Roman Catholic cathedral at Liver-pool, consecrated in May 1967, Mellor was chosen in collaboration with the sculptor Elizabeth Frink to make a silver altar cross and candlesticks in which Frink modelled the figure of Christ (fig. 124).

In the following decade difficult economic con-ditions led to a slackening in the pace of ecclesiasti-cal commissions. But a number of significant com-missions were carried out even so. Two leading fig-ures of this decade were Stuart Devlin and Brian Asquith. The most important of Devlin's commis-sions were an altar cross and alms dishes for Canter-bury Cathedral, characterized by simple geometric forms and the textured surfaces particular to his work (fig. 131). The Sheffield-born Brian Asquith attracted a number of local commissions, such as the 1974 chalice and ciborium for Derby Cathedral. The classic modern lines of Asquith's pieces are embellished with abstract texture evoking the water-falls of the Peak District, fitting perfectly with the Cathedral's simple interior and countered by the magnificent Bakewell wrought-iron screen and gates.

The single most important church commission of modern times, the Lichfield Service, emerged from a meeting between the Dean of Lichfield, Dr John Lang, and the author at Goldsmiths' Hall in 1990 (figs. 133–37). The Dean, who had raised a

Fig. 131 Alms dish, silver, parcel-gilt, Stuart Devlin, 1969 (Canterbury Cathedral)

Fig. 132 Altar cross, silver-gilt and enamel, Gerald Benney, 1963 (St Dunstan's Chapel, St Paul's Cathedral)

substantial fund for the purpose, asked whether there were creative silversmiths capable of producing a large suite of modern silver for use in the cathedral. Thus began my involvement as an honorary adviser with a year-long project. Sixteen selected silversmiths gathered in the cathedral on 14 February 1990. The great building made a powerful impression on them and its pillars, arches, clerestory windows, pulpit, floor tiles and even gargoyles all gave them design ideas. There was an extraordinary feeling of camaraderie which Gerald Benney summed up by saying, 'We are all taking part in something special'. A few months later the design drawings went before the design committee and it became clear that a remarkable collection was in the making. On 15 February 1991, exactly a year and a day after the gathering at the cathedral, the silversmiths delivered the finished pieces to Goldsmiths' Hall.

At the dedication in July the congregation were able to marvel at the processional cross by Gerald Benney (fig. 133) with its elegant use of ebony and silver complemented by masterly use of coloured enamel (inspired by Francis Skidmore's Victorian choirscreen). The sixteen silversmiths included six recent graduates of the Royal College of Art trained by Benney. Alex Brogden worked in collaboration with Benney to harmonize the design of his processional tapers. Jane Short made a beautiful enamel wafer box, the lid depicting the Holy Dove amid wheat and deep blood-red poppies. Richard Fox used a subtle inset of purple amethysts to enhance the simplicity of his plain chalice and paten. Michael Lloyd skilfully chased a rim of oak leaves symboliz-

Fig. 133 Processional cross from the Lichfield service, silver, ebony and enamel, Gerald Benney, 1990 (Lichfield Cathedral)

Fig. 134 The St Chad Cup (loving cup) from the Lichfield service, silver, parcel-gilt and patination, Kevin Coates, 1990 (Lichfield Cathedral)

ing strength of faith surrounding a central motif
of the Crown of Thorns on his offertory salver
(fig. 135), whilst Rod Kelly chased his large alms dish
with decoration relating to the Creation (fig. 136).
The Creation story also inspired Lexi Dick, in her
modelling of decorative sections of her offertory
salver. For many of these silversmiths this great com-
mission was their first for the Church, but several
have since gone on to produce major works for
other churches.

In 1998 James Fairbairn, Secretary to the Friends
of York Minster, asked me to advise on a project for a
new set of liturgical silver for use in the nave sanc-
tuary of the minster to mark the Millennium
(figs. 138–41). It was to consist of a cross and a pair
of candlesticks for the nave altar, a processional cross
and taper holders, a pair of ciboria, four chalices and
an alms dish. The process was very similar to that at
Lichfield. Funds were raised by an appeal; portfolios
from a selected list of designers were studied by the
design committee, and six designers were chosen to
submit designs in March 1999. Following only
minor amendments the completed pieces arrived at
the minster at the end of August 2000. The Dowager
Marchioness of Normanby donated the processional
cross by Gerald Benney in memory of her husband,
the 4th marquis, but most of the funds came from
numerous smaller donations from private individu-
als. Two thousand people attended the dedication
on 5 November 2000. The service was intensely
moving, witnessing contemporary silver bringing a
community together in that majestic minster with
its awesome atmosphere of faith and history.

Fig. 135 Offertory salver from the Lichfield service, silver and inlaid gold,
Michael Lloyd, 1990 (Lichfield Cathedral)

Fig. 136 Alms dish from the Lichfield service, silver and inlaid gold,
Rod Kelly, 1990 (Lichfield Cathedral)

Fig. 137 Wafer box from the Lichfield service, silver and enamel,
Grant Macdonald, 1990 (Lichfield Cathedral)

Alex Brogden was responsible for the great nave altar cross and candlesticks (figs. 140, 141), the centrepiece of the commission. The design of the taper holders by Jocelyn Burton was based on an ancient Roman torch, whilst the alms dish by Toby Russell echoed the stone tracery in many of the Minster's stained-glass windows (fig. 138). In the repertoire of the silversmith a chalice is one of the most demanding and profound vessels to make, since it is charged with bringing the congregation together in reconciliation. The chased bases of Michael Lloyd's four Minster chalices pay homage to the natural world, imbuing them with a simple spirituality that takes them beyond manufactured artefacts.

Finally, the ciboria for York Minster were by Rod Kelly. These followed his spectacular commission in 1999 for the great hanging pyx in St Dunstan's Chapel in St Paul's Cathedral, London, commissioned by the Friends of the Cathedral. In the first decade of the twenty-first century Rod Kelly has undertaken nine major ecclesiastical commissions, his superlative chasing skills enriching his silver surfaces with a juxtaposition of religious images which create powerful visual parables. Kelly also received the commission for another twenty-first-century ecclesiastical masterpiece, the massive and magnificent silver-mounted Bible, given to the Victoria and Albert Museum by the Whiteley Trust to celebrate the opening of the museum's new Sacred Silver and Stained Glass Gallery in 2005.

The role of the Goldsmiths' Company in church silver over the last half century has been pivotal, and

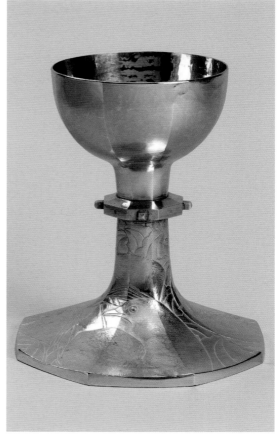

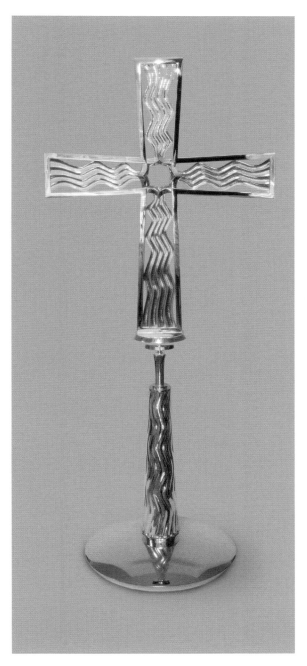

Facing page

Upper: Fig. 138 Alms dish from the York millennium service, silver, Toby Russell, 2000 (York Minster)

Lower: Fig. 139 Chalice from the York millennium service, silver and inlaid gold, Michael Lloyd, 2000 (York Minster)

Above: Figs. 140 and 141 Altar cross and candlestick from the York millennium service, silver, Alexander Brogden, 2000 (York Minster)

its influence, combined with the extraordinary creative ability of modern silversmiths, has led to contemporary design being favoured for new silver for churches during the last half century. The company continues today to advise patrons on commissions and to commission new works for its renowned collection.

The huge high altar cross by Geoffrey Clarke that the company gave Coventry Cathedral in 1958 was re-gilded with more permanent, hard gold-plating by Grant Macdonald in 2004. At the rededication service of the cross the cathedral was full of people for the festival of its patron saint, St Michael. The author attended this service with Geoffrey Clarke. He was deeply moved that so

many of the congregation went up to the altar afterwards and knelt on the hard stone in silent prayer before the cross. He turned to me and said: 'Artists have a responsibility to express the faith: I can say no more'.

Above
Fig. 140 Pair of chalices from the York Millennium service, silver, parcel-gilt, Wakely & Wheeler, 1960 (York Minster)

Facing page
Top: Fig. 143 Lavabo bowl and altar cruets, silver, parcel-gilt, Rod Kelly, 1998–2005 (New College, Oxford)

Lower left: Fig. 144 Chalice, silver, parcel-gilt, Richard Fox (Goldsmiths' Company)

Lower right: Fig. 145 Cruet stand from an altar set, silver and enamel, Hector Miller and Peter Musgrove, 1970 (St Joseph's Roman Catholic Church, Wool, Dorset)

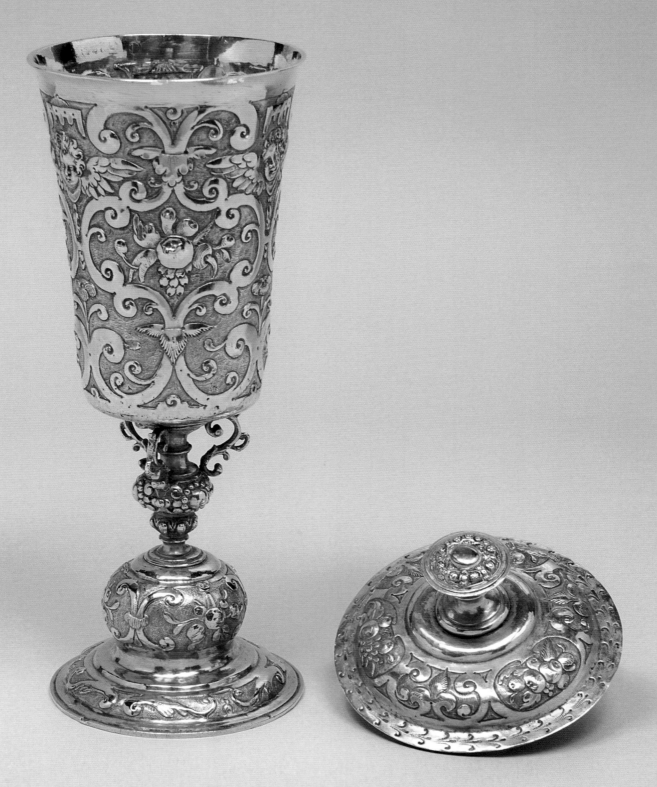

Fig. 146 Cup and cover, silver-gilt, Nuremberg, *c.* 1610 (Waltham-on-the-Wolds, Leics.)

Continental Plate in English Churches

Christopher Hartop

'… so often as he returned from beyond sea,
he brought along with him some ornament
or other'

Jocelin de Brakelonde (fl. 1173–1215)
writing of Abbot Samson of St Edmundsbury

We can only speculate about the quantities of foreign silver in English churches before the Reformation, for the surviving evidence is practically non-existent. But, given the cosmopolitan nature of the English Church in the Middle Ages, at least in the monastic foundations if not in the parishes, it is likely that Abbot Samson was not alone in enriching his abbey with foreign silver or gold. The new foundations which were set up in the years following the Norman conquest were daughter houses of French institutions, and we know that the importation of skilled craftsmen such as masons, and of materials such as stone, was regarded as essential. The exalted status of the goldsmith during this period meant that he, like the masons, was international in his scope, although, unlike the masonry, virtually none of the goldsmith's work survives.

Even before 1066, however, some church furnishings had come from abroad, such as the Byzantine paten presented to the shrine of St Cuthbert by Athelstan. The ninth-century Trewhiddle Chalice in the British Museum (fig. 12), found in Cornwall in the eighteenth century, may be an imported work given its similarities with Continental examples. But there are simply too few survivors, no marks of origin and little documentary evidence to form any sort of an accurate picture. The Ramsay Abbey incense boat from the fourteenth century, discovered in the Fens in 1851 and now in the Victoria and Albert Museum, is in an international style of plain surfaces and minimal ornamentation that is characteristic of so much plate made across western Europe, and only the presence of rams' heads at each end – thought to be a rebus, or visual pun – anchors it to Ramsay, and probably to an English workshop.

Trade, as well as pious abbots, brought foreign silver to England and some of this, too, must have found its way into parish churches as well as monasteries. The handful of surviving foreign secular

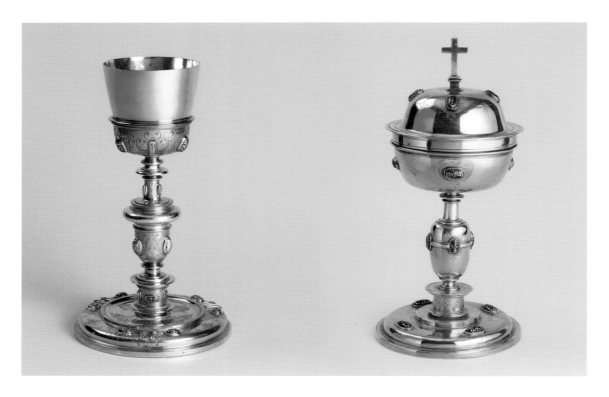

Fig. 147 Chalice and ciborium, silver-gilt and enamel, Spain, *c.* 1600 (York Minster)

pieces, such as the French gold cup of about 1380 that was acquired by Henry VI in 1435 (now in the British Museum) and the Avignon beaker given in the middle of the fourteenth century by William Bateman, Bishop of Norwich, to Trinity Hall, Cambridge, give us a glimpse of the international nature of the plate cupboards of those at the centre of affairs. The documentary evidence of foreign silver, at least in a domestic context, spreads down the social scale towards the end of the Middle Ages, with frequent references to French, Flemish, German and Spanish plate and, more specifically, to objects marked with the Paris or Rouen 'touch'. Henry III's Queen Eleanor had plate 'of Tours work' in 1253, as did Walter Stapleton, Bishop of Exeter and founder

of Exeter College, Oxford, in 1314, while by 1459 the self-made military adventurer Sir John Fastolf had '6 Paris Cups of silver'.

Frustratingly, these indications of marks and origin, which would often be familiar to the clerks who drew up aristocratic and royal inventories and were necessary to distinguish one object from another, appear all too infrequently in church documents. A rare instance is the mention of Byzantine silver objects in a 1295 inventory of St Paul's Cathedral, London. The origin of plate is never specified in the inventory of church goods commissioned by William de Swyneflete, Archdeacon of Norwich, in 1368. But it is tempting to assume that the pair of altar cruets and chalice listed as given to the church

at Helhoughton by Sir Robert Knollys, the notorious soldier of fortune, were booty taken by him from some French abbey or church.

After the Reformation, however, the picture is quite different. Foreign silver and gold survives in sufficient quantities in English churches, amassed during the last three and a half centuries, to enable us to consider the reasons why it was given. Often piety could be tempered with practicality. Plate, perhaps inherited, that was in outmoded style, as well as vessels rendered obsolete by changes of fashion in eating and drinking, often found their way into parish churches. Stricter controls over the goldsmith's trade from the reign of Elizabeth onwards meant that it became much more difficult to exchange outmoded foreign silver for new. With the exception of France, the legal alloy of most countries was well below the English sterling standard, which meant that its intrinsic value was much less than English hallmarked plate. After 1579 it was illegal to sell unmarked foreign wares, and as a result their trade-in value could be up to a third less than English silver. A gracious donation to one's parish church of family silver, perhaps advertising the

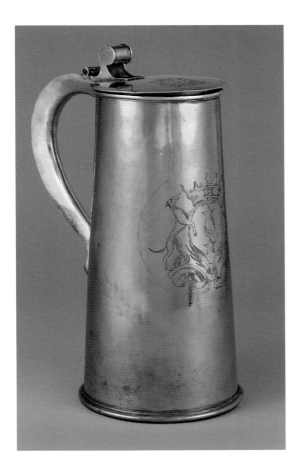
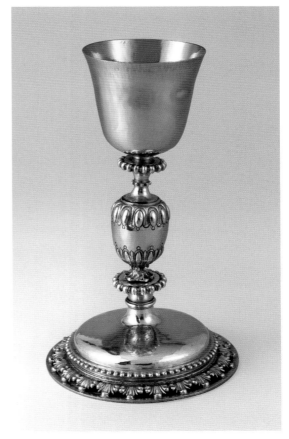

Figs. 148, 149 Flagon and chalice, silver-gilt, Paris, 1660; flagon, Charles Petit III; chalice, Denis Haudry II (Rushbrooke, Suffolk)

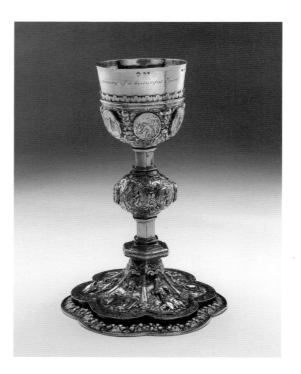

Fig. 150 Cruet stand (used as a paten), silver-gilt, probably Havana, early 18th century (Matson, Gloucs.)

Fig. 151 Chalice, silver-gilt, probably Antwerp, early 17th century (Haveringland, Norfolk)

family coat of arms, was sometimes the best way to extract benefit from an asset that was hard to trade.

Changes in church regulations could also create demand for donations. The Canons of 1604, which ordered that wine should be brought to the communion table in 'a pot or stoup of pewter if not of purer metal' (see p. 63) coincided with the start of the long decline of the domestic livery pot, spurring donations of flagons of both English and foreign manufacture. The tall Danzig tankards belonging to St Mary's, Combs, in Suffolk (fig. 159), dating from the second quarter of the seventeenth century, were used no doubt as livery pots by the forebears of their donor, Orlando Bridgeman, who was the local landowner and MP for Ipswich. Some time after

1716 he donated them to the church, which had a rapidly growing congregation, where they are described in an inventory of 1723 as 'Two silver flagons, curiously engraved'. Their finely engraved scenes of Adam and Eve, Cain and Abel and David and Saul were appropriate to both domestic and liturgical use. Similarly, the engraved scenes relating to food and drink on the eight-pointed Dutch domestic salver at Whatfield in Suffolk (fig. 158) could not have been regarded as inappropriate for its use as a paten when it was given to the church by Balteshazzar Martin at the beginning of the eighteenth century. Made in Amsterdam in 1636, the salver has elaborately engraved arms of the Martin family, which fill the centre. Their presence on the

communion table was no doubt felt by the donor to give a sense of permanence to his time at the manor, which he had purchased only in 1700.

Regions with strong trade links to the Continent, such as East Anglia, are especially rich in foreign plate. Commerce probably also brought a stunning Portuguese silver-gilt dish of 1500 to St John the Baptist, Bristol, to whom it was given by William Ellis, a local merchant who was also churchwarden (fig. 153). One of a rare group of Manueline tazzas decorated with the wild men which were so popular

Fig. 153 Embossed dish, silver-gilt, Portugal, c. 1500 (Diocese of Bristol)

in medieval decoration especially in Portugal and England, the tazza was originally a piece of domestic display plate. This fact was no doubt unknown when it was described at the time of its gift in 1629 as 'a piece of gilt plate for ye communion table'. The survival of this dish, with its rich figural decoration, is all the more surprising given the savage iconoclasm which tore through the English church in the 1640s and '50s. Although more vulnerable because of its intrinsic worth, silver could also be more easily concealed than other church ornaments.

The habit of giving plate acquired on overseas travels was widespread during the seventeenth century. The church at Bishopstone in Wiltshire was given a set of Cologne communion plate by Dr John Earles, who was rector between 1639 and 1662.

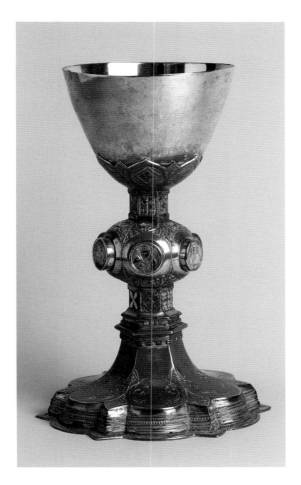

Fig. 152 Chalice, silver, parcel-gilt, gilded copper and enamel, probably Siena, 14th century (Westbourne)

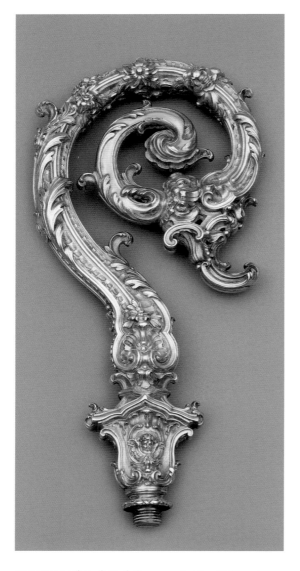

Fig.154 Crozier, silver-gilt, South Germany or Austria, mid 18th century
(Christ Church Cathedral, Oxford, and the Church Commissioners)

During the Interregnum he had gone into exile to the Low Countries, where he no doubt acquired the set. Henry Jermyn, 1st Earl of St Albans, gave the church at Rushbrooke, where he was lord of the manor, a set of communion plate made in Paris in 1660/61. Jermyn had been treasurer and confidant

to Queen Henrietta Maria during her exile and returned to England with her after the Restoration. The two chalices and patens in the set (fig. 149) follow the typical mid-century French Catholic form, but the flagon (fig. 148) is unprecedented in French silver. Of plain cylindrical form, its cover has a tubular thumbpiece of flat scrolls of a type popular in England in the mid seventeenth century but unknown across the Channel. While it is possible that Jermyn gave Charles Petit (recently identified as the flagon's maker)* an English example to copy, a more likely explanation is that it represents a unique survival of a French Protestant form of communion vessel. Louis XIV's persecution of the Huguenots, which culminated in his revocation of the Edict of Nantes in 1685, consigned all Huguenot communion plate to the melting pot.

Equally significant is the gilt chalice and paten belonging to St Katherine's Church, Matson, in Gloucestershire and now in Gloucester Cathedral treasury (fig. 150). Both pieces are inscribed 'Taken out of a Church at the Havannas by the Earl of Albemarle and given to George Augustus Selwyn by whom it was given to the Church at Matson'. Albemarle had led the British forces in their short-lived occupation of Havana in 1762, and Selwyn, who was lord of the manor of Matson, was his cousin. The two pieces, part of a small group of Spanish colonial pieces with a documented English provenance going back to the eighteenth century, are a valuable resource for scholars. Most of the silver made in colonial Latin America is unmarked and, in the upheavals of the past three centuries, has often been

*Information from Paul Micio.

moved far from its place of origin, hampering
attempts to analyse developments in form and deco-
ration in different regions. The paten is in fact a
stand for an altar cruet (useless in eighteenth-
century Anglican practice), with three circular
depressions for water and wine pots and a bell.
Contained in its original leather case, the set
presages the desire for richness in church plate
which would culminate in the next century. The
fact that they were originally made for Catholic use
seems not to have upset the sensibilities of Matson's
congregation. Indeed, from the Middle Ages
onwards, the provenance of liturgical silver seems to
have been of little concern to laymen or clergy. Items
could be refashioned or disposed of at will. It was
the consecrated wine and host, and, before the
Reformation, the relics themselves, that mattered.
But the Matson chalice and paten, with their proud
inscriptions, represent also a growing interest in the
provenance and historical associations of objects.
The Church in the eighteenth century was by no
means unaffected by antiquarianism, but its influ-
ence would reach new heights in the next century,
with foreign plate playing a significant role.

The seventeenth-century Nuremberg cup and
cover at Waltham-on-the-Wolds in Leicestershire
(fig. 146) was bought in 1842 by the incumbent from
Lambert's, the London dealers, for £14 10s, and paid
for with the proceeds from the sale of the 'old cup' –
presumably an Elizabethan one. The cup's rich dec-
oration must have contrasted starkly with the sober
Elizabethan communion cups of the neighbouring
parishes, and its acquisition is a good example of the

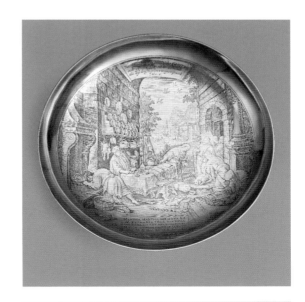

Figs. 155 and 156
One of a pair of tazzas, engraved with biblical scenes, Holland, *c.* 1600,
the engraving signed by Theodore de Bry (St John, Egham)

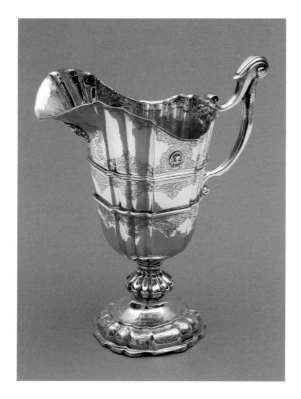

Top: Fig. 157 Ewer, silver, Augsburg, *c.* 1720 (Middleton Stoney, Oxon.)

Above: Fig. 158 Octagonal dish, silver, Amsterdam, 1636, engraved with the arms of the Martin family (Whatfield, Suffolk)

quest for objects which were felt, wrongly, to have authentic medieval decoration. A good example of the kind of object around which such romantic folklore grew up is the chalice made in Rome about 1700 by Flavio de Alessandris at Clare in Suffolk. Exactly when it was acquired is not known, but by the middle of the nineteenth century the object had acquired a 'provenance' involving a galleon of the Spanish Armada shipwrecked on the Suffolk coast at least a hundred years before its date of manufacture.

There were theological reasons, too, for this interest in objects from past ages. The Cambridge Camden Society – later the Ecclesiological Society – ransacked the Gothic past for models for its church silver, although only what were thought to be native English examples were deemed suitable, thereby avoiding the charge of imitating 'Romish' art. But for the Oxford Movement, and later the Tracterians, it was Continental Catholic plate that represented a continuous link with the purity of the pre-Reformation English Church.

The growth of the antique silver trade in the nineteenth century was fuelled not only by demand from collectors but also by demand for historical plate for churches. On this practical level, antique foreign church plate was far more readily available than its medieval English equivalent. In particular, the despoliation of monasteries in the Iberian peninsula threw on to the market quantities of objects such as ciboria, pyxes and candlesticks, all of which were in demand in England for the first time since the Reformation. The Tracterians' devotion to the Passion manifested itself in the acquisi-

tion of processional crosses and crucifixes, most of which came from Iberia. The Cathedrals of York, Chichester and Norwich all have sixteenth-century crucifixes from central Spain. As Robin Emmerson wrote in 1991, 'The Ritualists were seeking the authority of a tradition of worship for the same reason that the architects were copying past styles – in order to create a comforting illusion of security in a world that was changing very fast'.

The eclecticism of new church architecture was sometimes matched by the plate donated to be used in it. St Barnabas in Oxford, completed at the beginning of the twentieth century, was given a Russian Orthodox chalice and two patens dating from 1658/59. Other Continental pieces of various dates were supplied by the Art & Book Co., of Ashley Place, Westminster.

The tradition of donating attractive and useful Continental silver to the Church continues to the present day, although antique foreign silver is no longer a cheaper alternative to newly made plate, as it often was in the nineteenth century. York Minster boasts a handsome Spanish chalice and ciborium from the beginning of the seventeenth century (fig. 147). Their bold massiveness is in what Charles Oman dubbed the 'Herrera style', after Juan Herrara, the architect of El Escorial. Their gift by Dean Milner White after the Second World War recalls Abbot Samson and his gifts 850 years before. Foreign silver is without doubt the most varied of the many strands that decorate and embellish churches across the country. It makes for a very rich tapestry indeed.

Fig. 159 One of a pair of tankards, silver, Danzig, 2nd quarter 17th century (St Mary's, Combs, Suffolk)

Fig. 160 Communion cup and cover, silver-gilt, 1568, maker's mark TF (St Mary-le-Bow)

The Parish and its Plate
The Case of St Mary-le-Bow

Timothy Schroder

There is no better witness to the multi-layered history of a parish than its plate. Its evolving topology, its people, their beliefs and prosperity are all reflected in these objects. A case in point is the church of St Mary-le-Bow, one of the dozens of churches scattered across the medieval city of London. Along with many others it was destroyed in the Great Fire of 1666 and again in the Blitz of 1941. But, burnt out though so many buildings were, the fire in 1666 had spread quite slowly and most of London's church plate was saved. Prescient removal to safe-keeping once again saved most of it from the ravages of the Blitz and ensured that it would survive to bear witness to a remoter past.

As one of the most important and famous of London's churches, there was no question that St Mary-le-Bow would be rebuilt, and in the post-Fire reorganization the new parish swallowed up its neighbours, All Hallows Honey Lane and St Pancras Soper Lane. A further amalgamation in 1878 merged the parish with several others, including All Hallows Bread Street, followed after the Second World War by St Mildred Bread Street and St Augustine Watling Street (which had already absorbed St Faith under St Paul's).

In the context of the long history of St Mary-le-Bow, first built around 1080, its earliest surviving piece of plate, dating from the sixteenth century, is not especially old. The reason for the disappearance of its medieval plate, along with that of almost every other City church, was the Reformation. London, close as it was to the heart of government and home to many of the most radical theologians of the day, was swift and wholehearted in its response to the evangelical calls to sweep away the trappings of traditional religion.

The iconoclasm of Edward VI's reign (1547–53) led to the destruction of images, altarpieces and stained glass. Churches had to pay for wall paintings to be whitewashed over and for rood screens to be removed. Surplus and 'idolatrous' plate – monstrances, reliquaries, processional crosses and censers – was melted down and only those items essential to the celebration of the Lord's Supper, the chalice and paten, were retained. In the most radical churches even the chalice, with its popish

and 'magical' overtones of transubstantiation, was melted down and replaced by a new, plain and demythologized cup with a bowl large enough to administer communion to the entire congregation.

The evangelical regime of Edward's reign was too short to effect a general transformation of English communion plate and only in London was there much of a move towards the new style of cups. One of the earliest of all is the 1549 cup of St Mary Aldermary (fig. 30), which is decorated not with religious symbols but with the royal arms to symbolize the crown's authority in the church. Of exactly the same date is a very similar cup, originally belonging to St Mildred Bread Street, which is even more austere, having no decoration at all other than a band of boldly struck die-stamped foliage around the foot.

With the death of Edward came the equally brief return to Rome under Mary I (1553–58) and a reversal of the previous iconoclastic policy. Altars were reinstated, images restored and the plundering of church plate brought to a halt. But in practice government policy was moving against the tide. Time and resources were too limited for Mary to undo completely what had been done by her brother and, with the start of Elizabeth I's reign in 1558, evangelical principles, if with a slightly less radical agenda, were soon reaffirmed. Under Archbishop Parker and Bishop Grindal of London, the conversion of chalices continued and was organized on a national scale (see Chapters 3 and 4). This took time to complete but naturally the process started in London, where it was easier to supervise and where it was less opposed than in more remote parts of the

country, which were religiously more conservative than the capital.

An extraordinary number of communion cups survive from the late 1560s and 1570s. Whether from a liturgical or visual point of view, this was the period when the English Church first became recognizably what it is today: interiors were again whitewashed and stripped of ornament, altars or communion tables were pared down to a bare minimum, and plate was remade into vessels, many of which remain in regular use to this day.

The earliest Elizabethan communion cup at St Mary's, hallmarked for 1559, is reminiscent of the Edwardian form in its stem, but several others, including one of 1568 made for St Faith's, are typical of the standard formula. Another, formerly at All Hallows Honey Lane (fig. 160), looks back to the more radical climate of Edward's reign in having inscriptions reading 'Blessed is God in all hys Giftes' on the cup and 'Christ is the bread of lyfe' on the paten. Such sentiments are a pointed rejection of the miraculous character of the Mass and an affirmation – by the Elizabethans – of its true function as a commemoration of Christ's sacrifice.

Recognizably English though the Elizabethan Church may have been, it did not stand still. As the sixteenth century advanced and moved into the seventeenth, plate began once again to play a more prominent role in church liturgy and ceremony. The communion cup was joined on the altar by the alms dish, to emphasize the role of Christian charity, and the flagon, to store and dispense wine into the cup. Not all parishes possessed a silver alms dish and the

earliest at St Mary's is a completely plain example of 1684 formerly at St Margaret Moyses. But there are no less than eight flagons among the combined resources of the united parishes.

Whereas the conversion of the old chalices had often been a self-financing operation (the goldsmith being paid with some of the metal from the chalice), the re-equipping of the plate collections with further new pieces depended largely on the generosity of patrons and parishioners. Sometimes this might be with money given for the purpose, but more often it was in the form of surplus or old-fashioned plate taken out of domestic use and given to the church. This was particularly the case with alms dishes and flagons. The former might originally have been used with a ewer for rinsing the hands at table and the latter as containers for wine or ale. As such they are often older than their inscriptions imply.

The earliest flagons at St Mary's are typical of such gifts. Made in 1617 and originally from St Mildred Bread Street (fig. 165), these are exceptionally large and weigh a total of 94 ozs. Worth £25 or more at the time, they would have been a valuable asset. They were given about twelve years after they were made and are engraved with the donor's arms and an inscription stating their purpose and perpetuating his memory: 'These Pots are ye Guift of Capt. Nicholas Crisp for ye perpetual use of ye Holy Sacrament of ye Lord's Supper in ye church of St Mildred's in Bread Street in London Ano. Dom. 1631'.

Inscriptions are the life-blood of historic plate. Sometimes they simply record ownership, perhaps as a protection against theft, such as 'St Augustines

Parish' on a paten of 1577 or, more minimally still, '1595 SF', on another from St Faith's. But often they record the origins of an object and perpetuate the memory of its donor too. The identity of 'MM' in the case of 'The gift of MM to the parish church of St Faiths under Pauls', on a communion cup and

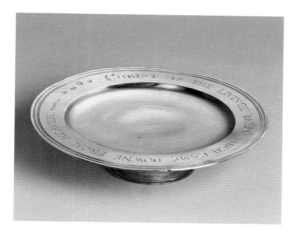

Figs. 161, 162
Pair of patens, silver-gilt, 1623, maker's mark CB (St Mary-le-Bow)

Fig. 163 The parish seal, showing the church tower as it appeared
in the 16th century, silver and brass, dated 1580 (St Mary-le-Bow)

paten of 1664, has perhaps faded with time but
others, for example, 'The Gift of Ralph Tunstall to
Saint Augustine's church 1631' or 'The gift of Samuel
Langham Grocer', leave a clearer trail.

Some have a distinctly legalistic flavour, such as
that on a flagon of 1640 from St Faith's, which is
engraved with the arms of the Stationers' Company
and *'Ecclesiæ parochiali Stæ Fidis donavit Gulielm
Aspley stationari præter 5 libras paupis legatas qui
obiit 18 Dec. 1640'* (William Aspley, Stationer, who
died 18 December 1640, gave this to the parish
church of St Faith, in addition to five free legacies to
the poor).

Associations with City livery companies are
prominent in many inscriptions and one of the
most interesting is on a pair of silver-gilt patens of
1623 (figs. 161, 162). Around the rims is a quotation
from John's Gospel, 'Christ is the livinge bread,
which came downe from Heaven', while a more sec-
ular message is on the reverse, engraved around the
arms of the Goldsmiths' Company and reading 'The
gift of Gilbert Harryson Goldsmith, Al Hallowes
Hony Lane 1623 . Here is theology, pride of associa-
tion and self-perpetuation brought neatly together.
Harryson (*c.* 1581–1651) was a high flier. He served a
normal goldsmith's apprenticeship and was free of
the company in 1604. He joined the livery in 1622,
the year before this gift, and became Prime Warden
in 1634. The following year he was made a sheriff
and in 1645 Chamberlain of London.

Perhaps the most evocative of all the inscrip-
tions on silver connected with St Mary's is that on
the parish seal (fig. 163). This is engraved around the
edge *'Sigillum Eccliæ Beatæ Maria de Arcubus Lon-
dini 1580'*, with a clear image of the medieval tower
of the church in the centre. Although we have at
least two other images of the old tower – in the 1547
panorama of Edward VI's coronation procession as
it passed along Cheapside and on a 1560 copperplate
map of London – this is by far the most detailed,
showing clearly defined stonework with typical
Tudor mouldings over the windows and a large
clockface below. The top of the tower is castellated,
with four 'pepper pot' turrets at the corners and a
larger central turret apparently supported on iron or
masonry brackets.

In Oxford and Cambridge colleges and some livery companies, where an unsentimental attitude to plate tended to prevail, it was common for worn-out or redundant plate to be melted down and remade into something more suitable, the original donor's inscription being transcribed on to the new piece as a matter of record. A similar custom is sometimes evinced in church plate and a number of pieces at St Mary's bear inscriptions that reflect a history of changing use. From St Margaret Moyses, for example, are two pieces, the alms dish of 1684 referred to above and a large paten of 1741 by Humphrey Payne. Both were recycled from earlier objects, though what exactly they were is not known. The alms dish is inscribed 'I∗H 1631', a date 53 years earlier than its hallmarks. The paten was evidently also recycled from part of the same 1631 gift, although in this case the addition of some new silver was required too: the inscription on the reverse reads, 'This plate was new made with an addition of five guineas by ye Revd. Dr. Mangey 1741'.

This custom of recycling old plate continued until almost our own times, and a particular group of plate from St Augustine's allows us to track the process in some detail. The name of Samuel Langham first appears on a very worn early seventeenth-century paten. In regular use at St Mary's today, however, is a Victorian silver-gilt chalice and paten of 1859 in late Gothic Revival style by the well-known church-plate maker John Keith (fig. 164). The chalice is engraved on a plate under the foot 'This chalice was made out of one the gift of Samuel Langham, grocer, AD 1630 and a portion of another

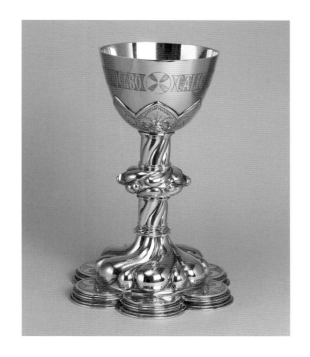

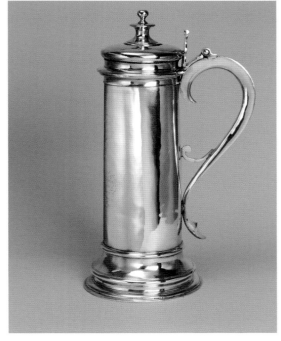

Top: Fig. 164 Gothic revival chalice, silver-gilt, by John Keith, 1859 (St Mary-le-Bow)

Above: Fig. 165 One of a pair of flagons, silver, 1617, maker's mark CC (St Mary-le-Bow)

the property of the parish of St Augustine', while the
paten was made 'out of the remaining portion of a
chalice, 1608'.

The story of the plate of St Mary-le-Bow
does not end with a nineteenth-century retread.
Although made of polished steel rather than silver,
two recent acquisitions, one a gift of its patron, the
Grocers' Company, have enormously enriched the
church's holdings of silver-like metalwork. A pair of
altar candlesticks (fig. 166) and an enormous paschal
candlestick, both by Simon Robinson, are highly
original works of art. The paschal candlestick in par-
ticular restates a traditional theme with a remark-
ably new voice that has a dramatic and sculptural
presence in the church. Like the church itself, the
plate of St Mary-le-Bow and the other parishes it has
absorbed is steeped in the history of the site, of both
the parish and its people, but it reflects the present as
well as the past and it is to be hoped that from time
to time its holdings of plate will continue to be aug-
mented with new commissions or gifts.

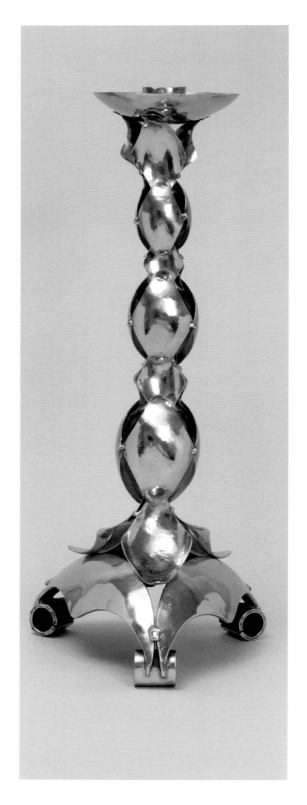

Fig. 166
One of a pair of candlesticks, polished steel, Simon Robinson, 2005
(St Mary-le-Bow)

This chapter is abridged from that originally published as
'St Mary-le-Bow's Silver Collection' in *St Mary-le-Bow, A History*
(ed. Michael Byrne and G.R. Bush, London, 2007).

Cathedral Treasuries and the Goldsmiths' Company

Susan Hare

When writing his great book *English Church Plate* in the 1950s, Charles Oman, then Keeper of Metalwork at the Victoria and Albert Museum, had discussions with the Central Council for the Care of Churches, who were dismayed by the quantities of church plate held in bank vaults, in many cases over decades, and, as a result, of little or no interest to the parish priest. As the objects were not in use, they became prime targets for disposal by incumbents and church wardens anxious to raise money for church repairs.

The Council approached the Goldsmiths' Company in 1957 with the suggestion of setting up diocesan treasuries, mainly to be housed in cathedrals. The Goldsmiths' Company, advised by Sir Edward Ford, whose father had been Dean of York Minster, held the view that clergy and church wardens were custodians, for the time being, of treasures which had been in the possession of the churches often for hundreds of years, and that they had no right to sell them. The company therefore decided to inaugurate a scheme for setting up diocesan treasuries in the hope of renewing interest in plate in the clergy and of stimulating public appreciation of fine workman-

ship, to bring more visitors and perhaps some added income to the cathedrals concerned. Over the following decades it granted a total of some £300,000 towards a number of cathedral treasury schemes up and down the country.

The treasury of Lincoln Cathedral was the first. Designed by Louis Osman, it opened in 1960 under its first curator Peter Hawker, a keen historian of church plate. It brought back into use an Early English chapel in the North transept and was an instant success, bringing in several hundred pounds profit to the cathedral.

A second treasury was opened in Winchester Cathedral in 1969, designed by Alan Irvine, with Patrick Preston acting as curator. It is sited on a fourteenth-century platform at the west end of the North aisle, formerly used for the consistory court. Unfortunately this has not been so successful, as many elderly people, often the volunteers willing to man it, found the steps too dangerous to climb.

York Minster treasury, designed by the architect Bernard Feilden, formed part of his huge programme of reconstruction in the crypt, opened in

THIS TREASURY WAS CREATED THROUGH
THE GENEROSITY OF THE WORSHIPFUL
COMPANY OF GOLDSMITHS OF LONDON

1972. Initially the exhibits were all grouped by parish; now overseen by staff of the York Museum, the installation has been reorganized with a more historical layout.

Norwich Cathedral treasury, designed by Stefan Buzas and opened in 1973, has from the start been a great success. It is sited in the fifteenth-century reliquary arch in the north choir aisle, above which are some of the best Romanesque frescoes in northern Europe. The first curator was the Revd James Gilchrist, author of *Anglican Church Plate*. Always with the active support of the staff of Norwich Castle Museum, it is now curated, most enthusiastically, by Nigel Bumphrey.

With great enterprise and without financial support from the Goldsmiths' Company, Ripon Cathedral opened its treasury in the seventh-century crypt. Unfortunately, however, the insertion of glass cases into the early stonework incurred widespread criticism and it had to close. The Goldsmiths' Company subsequently granted funds for the purchase of secure cases now situated in the choir transepts.

The Norman Chapter House in Christ Church Cathedral, Oxford, was also opened as a treasury in 1976. The funding for this was mostly raised by the Dean and Chapter, with some assistance and advice from the Goldsmiths' Company. An initially ideal scheme was later spoiled by a decision to move the Cathedral shop into the same space. Racks of sweatshirts, books and souvenirs now hang beside the glass cases. The dignity of the displays is inevitably compromised and there is little room to move about.

A particularly successful treasury is that at Chichester Cathedral, designed by Alan Irvine, which also opened in 1976. This is probably the largest so far, with room for the display of embroidered vestments as well as a wide range of cathedral and diocesan plate. It was set up with full financial support from the Goldsmiths' Company.

Also from 1976 was the treasury at Durham Cathedral, which was also partly funded by the Company. Despite including some of the most splendid church plate in the country, it was initially a rather confused display, mixing artistic treasures with archival items and somewhat unsatisfactorily sited in the crypt area opposite the cafeteria. A few years later it was moved to a more suitable position and reinstalled to a highly professional standard. But the range of material displayed, concentrating as it does on the cathedral's own holdings, is so rich and varied that it can hardly be described as a diocesan treasury in the usual way.

Another very successful treasury was opened in 1977 in Gloucester Cathedral, designed by Gordon Bowyer. It is housed in the cathedral slype with an entrance cut through the wall from the north transept (fig. 167). It benefited hugely from the enthusiasm, knowledge and dedication of Owen Parsons, curator until his death in 1986. This also had full financial support from the Goldsmiths' Company.

There were plans to open a treasury at Canterbury as early as 1972, in the late medieval water tower. These did not progress further as there was some resistance from the then Dean and Chapter and also the area would have been far too small.

Fig. 167 View of Gloucester Cathedral treasury, with the arms of the Goldsmiths' Company

However, the idea was revived in 1977, to be built at the west end of the crypt, designed by the architect Robin Wade. This was opened in 1980 under the first curator, Canon Ingram Hill, who was able to collect a large quantity of interesting items, both from the various safes in the cathedral and from many parishes in the diocese. The author is now the honorary curator and my main task is to exhibit the pieces, beginning with an Anglo-Saxon miniature sundial (fig. 8), in chronological order. Fortunately a strong room had been made, under the same treasury security, so that a large number of duplicate pieces, particularly Elizabethan communion cups, can be swapped at intervals.

In 1981 the north transept of the crypt of St Paul's Cathedral, London, a space formerly walled off as a store room, was made available by the Dean and Chapter. As a result of the Union of Benefices Act of 1860, at least ten city churches vanished, with plate surviving from most of them. Tragically, much of the cathedral's own plate was stolen in 1860, when thieves removed nearly 2,000 ozs of silver from the strong room, and new replacement silver was not purchased until 1870. At the time of the opening of the treasury Philippa Glanville was a curator at the Museum of London and generously gave her expertise and time for the selection and arrangement of the display. Unfortunately this professional involvement did not continue. The Museum of London no longer has a connection with the cathedral and the treasury was temporarily closed some time ago.

The former library at Peterborough Cathedral, built originally around 1370 as a chapel of the Holy Trinity high above the west porch, became the treasury there in 1981, designed again by Stefan Buzas. With Canon Christie in overall charge, it was initially popular because of the friendly atmosphere. But, in spite of its attractive location, this was also felt to be less successful as time went on because of the number of stairs one had to climb to gain access, and also because volunteer guides, often elderly, felt vulnerable high up in an area cut off from the rest of the cathedral. Happily, the treasury has since been relocated to a more accessible part of the building.

The involvement of the Goldsmiths' Company with the treasury programme continued into the 1980s. In 1983 the company made a £5,000 grant to Salisbury Cathedral towards the cost of preparing the circular chapter house, mainly for the display of the cathedral's copy of Magna Carta – an extremely popular attraction – but with extra cases around for the display of church plate. Once again, this was the work of Stefan Buzas. Grants were also made at this time for displays in Hereford (now closed), Lichfield Cathedral and St Alban's Abbey. Exceptionally, Newark parish church was granted funds towards a treasury in view of its exceptional holdings of plate.

In 1985 the wardens of the company were approached for financial help towards a similar scheme in Westminster Abbey. This would not be a diocesan treasury as the collegiate church of St Peter in Westminster is a Royal Peculiar and is therefore extra-diocesan, coming under the personal jurisdiction of Her Majesty the Queen. The fact that the proposed treasury was to be housed in the chamber that had association with the Trial of the Pyx, in

which the Goldsmiths' Company had been involved since 1248, helped the wardens to decide to allocate funds towards the provision of two showcases, designed by Paul Williams. Opened in 1986, the first case consists of large and richly chased silver-gilt altar plate of the late seventeenth century, also some twentieth-century pieces by Omar Ramsden, the most important maker of church plate of his time. The second case holds the plate of St Margaret's Church, Westminster, including a pair of communion cups of 1551 by Robert Taylboyes and a pair of flagons of 1584. Philippa Glanville, then Assistant Keeper in the Department of Metalwork in the Victoria and Albert Museum, took on the task of displaying and describing the plate.

The involvement of the Goldsmiths' Company did not end with the granting of funds. At the start of the scheme, Charles Oman was appointed the company's Inspector of Treasuries and travelled the country visiting each exhibition, giving much-needed help with reading hallmarks and other problems and sending written reports back to the company. In 1983 he was succeeded as Adviser for the Diocesan Treasuries by Claude Blair. He, too, regularly visited them all, writing full and frank reports of his findings. In 1989 the company decided to discontinue this role, hosting instead periodic cathedral treasury conferences as a forum for general discussion. In the mid 1980s, although there were still some schemes in the pipeline, the wardens took stock of the situation and, while agreeing that it had, on the whole, been successful and had achieved beneficial results for the cathedrals concerned, noted the ever-

increasing cost of installing treasuries and stated that the Goldsmiths' Company would not be able to provide them indefinitely. They agreed, however, to offer moderate financial support to any other body which was prepared to undertake the financial burden. Expert advice would still be provided by the staff when required.

Fig. 168 Anthony Elson, design for a chalice for Lincoln Cathedral

Treasures of the English Church – Envoi

The Rt Revd and Rt Hon Richard Chartres, Bishop of London

The exhibition that gave rise to this book reveals the Christian community in England as a tenacious guardian of the cultural inheritance of the whole English people. Despite periods of iconoclasm and neglect many treasures have survived the ravages of time to carry a message from centuries past to our own day.

But what of the future? To judge from the recent commissions for Lichfield and York, the stream of inspiration is far from exhausted. But the retreat of the sea of faith has been reflected in the design and execution of the signs and tokens of divine worship.

Genuine simplicity always reflects one aspect of the divine mystery but the cult of rude pottery cups for use in the communion service goes further and reflects disenchantment.

At the same time the profusion of commemorative pieces in silver suggests a community that experiences what the poet David Jones described as 'the sagging end and chapter's close', as we attempt to celebrate the mysteries in the 'cramped repeats' of earlier forms.

Another feature of our time has been the hypocritical indignation poured out on the use of precious metal and costly objects in the public worship of the Church. I remember someone who lived in very comfortable circumstances in Hampstead expressing horror at going to a church in a poor part of India in which a wealth of ornament and altar furniture was on display. Poor communities are often wiser in preferring public glory which all can enjoy to the private opulence and public squalor which seems to be fashionable among us.

At the same time a world of marvels has been revealed through microscope and telescope which has yet to be fully honoured and incorporated in the language of our design and symbolism. This is a time of waiting, while some of the nerve ends of the world become aware that the extreme ebb of the tide of faith is a sign of an approaching spiritual tsunami with a potential for destruction and re-creation.

Some of the most confident prophecies about our own century have already proved embarrassingly wrong. Writing in the *New York Times* in 1968, in the decade of love and flower power, the cele-

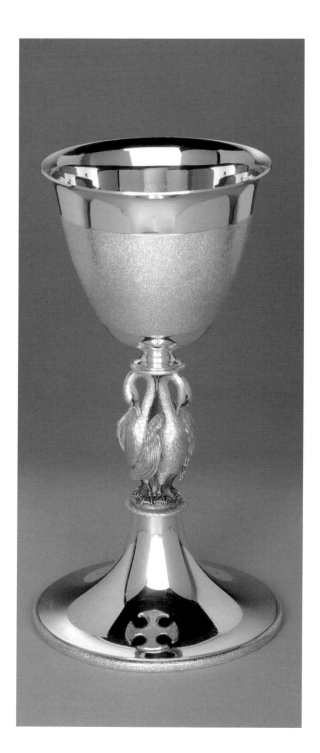

Figs. 169, 170 Chalice and design, the chalice silver, parcel-gilt, Anthony Elson, 2000 (Lincoln Cathedral)

 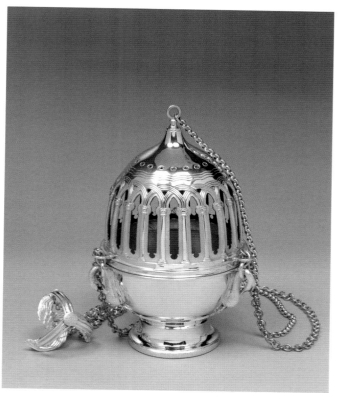

Figs. 171, 172 Censer and design, the censer silver, Anthony Elson, 2008 (Lincoln Cathedral)

brated American sociologist Peter Berger prophesied that 'by the twenty-first century religious believers are likely to be found only in small sects, huddled together to resist a world wide secular culture'.

By 1999 the same Berger had written a book entitled *The Desecularization of the World* in which he stated his thesis thus: 'The assumption that we live in a secularized world is false. The world today, with some exceptions, is as furiously religious as it ever was, and in some places more so than ever.'

The renewal of the apprehension of the sacred will continue to express itself in precious stone and metal and there are Christian centuries to come which will more than equal the glories on display in *Treasures of the English Church*. At the same time, as always, genuine originality will not simply be a matter of expressing what is most obvious to us about contemporary experience but of marrying that experience to a sympathetic appreciation of past forms. I hope that some young visitor to this exhibition will be inspired to create an authentically twenty-first-century treasure which will refresh our vision of the intersection of the divine mystery and our daily life.

*+ **Richard Londini***

GUIDE TO FURTHER READING

General

Catalogue of Silver Treasures from English Churches, London (Christie's), 1955

Helen M. Clifford, *A Treasured Inheritance: 600 Years of Oxford College Silver*, Oxford (Ashmolean Museum), 2004

Robin Emmerson, *Church Plate*, London, 1991

James Gilchrist, *Anglican Church Plate*, London, 1967

C.C. Oman, *English Church Plate 597–1830*, London, 1957

E. Alfred Jones, *The Old Silver Sacramental Vessels of Foreign Protestant Churches in England,* 1908

Timothy Schroder, *Silver and the Church,* London (Goldsmith's Company), 2004

County and Diocesan Plate Surveys

For a comprehensive list of published local inventories of church plate, arranged under counties, see Oman 1957; since then relatively few new titles have appeared in print.

St Dunstan, Patron Saint of Goldsmiths

J. Backhouse *et al.*, eds., *The Golden Age of Anglo-Saxon Art 966–1066*, London (British Museum), 1984

J. Backhouse and L. Webster, eds., *The Making of England – Anglo-Saxon Art and Culture AD 600–900*, London (British Museum), 1991

E. Coatsworth and M. Pinder, *The Art of the Anglo-Saxon Goldsmith. Fine metalwork in Anglo-Saxon England: its practice and practitioners*, Ipswich, 2002

D.J. Dales, *Dunstan – Saint and Statesman,* Cambridge, 1988

R. Gameson, *The Role of Art in the Late Anglo-Saxon Church,* Oxford, 1995

N. Ramsay *et al.*, eds., *St Dunstan – His Life, Times and Cult,* Ipswich, 1992

D.M. Wilson, *Anglo-Saxon Art from the Seventh Century to the Norman Conquest,* London, 1984

Church Plate before the Reformation

J.J.G. Alexander and P. Binski, eds., *The Age of Chivalry,* London (Royal Academy of Art), 1987

C. Burgess, 'Time and Place: The Late Medieval English Parish in Perspective', in *The Parish in Late Medieval England*, ed. C. Burgess and E. Duffy, Donington, 2006

J. Catto, 'Religious Change under Henry V', in *Henry V: The Practice of Kingship*, ed. G. Harriss, Oxford, 1985

Eamon Duffy, *The Stripping of the Altars: Traditional Religion in England, 1400–1580*, 2nd edition, London, 2005

A. Hamilton Thompson, *The English Clergy and their Organization in the Later Middle Ages*, Oxford, 1947

P. Heath, *Church and Realm, 1272–1461,* London, 1988

R. Marks and P. Williamson, eds., *Gothic – Art for England 1400–1547,* London (Victoria and Albert Museum), 2003

R.W. Southern, *Western Society and the Church in the Middle Ages,* Harmondsworth, 1970

George Zarnecki, ed., *English Romanesque Art 1066–1200,* London (Hayward Gallery), 1984

The Tudor Reformations and 'Decent Communion Cups'

Margaret Aston, *England's Iconoclasts,* Oxford, 1988

Eamon Duffy, *The Voices of Morebath,* New Haven and London, 2001

Edwin Freshfield, *The Communion Plate of the Churches in the City of London*, London, 1894

Christopher Hartop, *East Anglian Silver 1550–1750*, Cambridge, 2004

Diarmaid MacCulloch, *Tudor Church Militant*, London, 1999

Robert Whiting, *The Reformation of the English Parish Church*, Oxford, 2009 (forthcoming)

Joyce Youings, ed., *The Dissolution of the Monasteries,* London, 1971

From Buffet to Altar: Secular Plate in Anglican Churches

Philippa Glanville, *Silver in Tudor and Early Stuart England*, London, 1990

E. Alfred Jones, *The Old Silver of American Churches,* 2 vols, Letchworth, 1913

P. Kane, *Colonial Massachusetts Silversmiths and Jewellers: A Biographical Dictionary,* New Haven, 1998

P. Morgan, ed., 'Inspection of Churches … in Worcestershire 1674, 1676, 1684 and 1687', *Worcestershire Historical Society*, New Series, vol. 12, 1986

S.L. Ollard, ed., 'Archbishop Henry's Visitation Returns 1743, *Yorkshire Archaeological Society*, vol. LXXIX, 1929–31

W.R. Ward, ed., *Parson and Parish in Eighteenth-Century Hampshire; Replies to Bishops' Visitations*, Winchester (Hampshire County Council), 1995

A Broad Church: Anglicanism in the Seventeeth and Eighteenth Centuries

Gerald Bray, ed., 'The Canons of 1603', in *The Anglican Canons 1529–1947*, Church of England Record Society, vol. 6, 1998

Julian Davies, *The Caroline Captivity of the Church: Charles I and the Remoulding of Anglicanism 1625–1642*, Oxford, 1992

Kenneth Fincham and Nicholas Tyacke, *Altars Restored: The Changing Face of English Religious Worship 1547–c. 1700*, Oxford, 2008

W.M. Jacob, *Lay People and Religion in the Early Eighteenth Century*, Cambridge, 1997

Peter Lake, 'The Laudian Style: Order, Uniformity and the Pursuit of the Beauty of Holiness in the 1630s', in *The Early Stuart Church*, ed. Kenneth Fincham, Basingstoke, 1993

John Morrill, 'William Dowsing and the administration of iconoclasm in the Puritan revolution', in *The Journal of William Dowsing: Iconoclasm in East Anglia During the Civil War*, ed. Trevor Cooper, Woodbridge, 2001

Graham Parry, *The Arts of the Anglican Counter Reformation: Glory, Laud and Honour*, Woodbridge, 2006

Recusant Plate in England

Peter Cameron, 'Henry Jernegan, the Kandlers and the client who changed his mind', *Silver Society Journal*, vol. 8, 1996, pp. 487–501

- Edward Norman, *Roman Catholicism in England from the Elizabethan Settlement to the Second Vatican Council*, Oxford, 1985

C.C. Oman, *English Church Plate, 597–1830*, Oxford, 1957, pp. 257–86

C.C. Oman, 'The Plate of the Chapel of the Sardinian Embassy', *Burlington Magazine*, vol. CVIII, October 1966, pp. 500–03

C.C. Oman and David McRoberts, 'Plate made by King James II and VII for the Chapel Royal of Holyroodhouse in 1686', *The Antiquaries Journal, Journal of the Society of Antiquaries of Scotland*, vol. 48, part 2, 1968, pp. 285–95

Petre family manuscripts (deposited in the Essex Record Office, Chelmsford)

The Victorian Resurgence

B. Brooks, *The Gothic Revival*, London, 1999

J. Mordaunt Crook, *William Burges and the High Victorian Dream*, London, 1981

A.W.N. Pugin, *Contrasts; and The True Principles of Pointed or Christian Architecture*, reprint, Reading, 2003

J.S. Reed, *Battle Glorious: the Cultural Politics of Anglo-Catholicism*, Nashville, 1996

James White, *The Cambridge Movement: the Ecclesiologists and the Gothic Revival*, Cambridge, 1962

Victorian Church Art, London (Victoria and Albert Museum), 1971

Church Plate in the Early Twentieth Century

Graham Hughes, *Modern Silver Throughout the World 1880–1967*, London, 1967

Annelies Krekel-Aalberse, *Art Nouveau and Art Deco Silver*, London, 1989

Eric Turner, 'Great Britain', in *Silver of a New Era, 1880–1940*, ed. Joost Willink, Rotterdam (Museum Boymans-Van Beuningen), 1992

Church Plate since the Second World War

Martin Ellis, *Eric Clements: Silver and Design, 1950–2000*, Birmingham (Birmingham Museum and Art Gallery), 2001

Graham Hughes, *Gerald Benney Goldsmith*, London, 1998

Lichfield Cathedral Silver Commission, Lichfield, 1991

The Millennium Silver [of] York Minster, York, 2000

Jenny Moore, *Louis Osman 1914–1996*, Halsgrove, 2006

Rosemary Ransome Wallis, *Treasures of the 20th Century*, London (The Goldsmiths' Company), 2000

Robert Welch, *Hand and Machine*, London, 1986

Continental Plate in English Churches

Marian Campbell, 'Gold, Silver and Precious Stones', in *English Medieval Industries: Craftsmen, Techniques, Products*, ed. J. Blair and N. Ramsay, London, 2001

Sir Ernest Clarke, *The Chronicle of Jocelin de Brakelond*, London, 1907

First published 2008

ISBN 978 1 903470 74 9

British Library Cataloguing in Publication Data
A catalogue record for this book is available from the British Library

Produced by Paul Holberton publishing
89 Borough High Street, London SE1 1NL
www.paul-holberton.net

Book interior designed by Strule Steele

Printed by 𝒞𝖦𝖱𝖠𝖯𝖧𝖨𝖢, Verona, Italy

New photography by Richard Valencia, Jonathan Tickner,
David Mocatta and Jeremy Moeran.

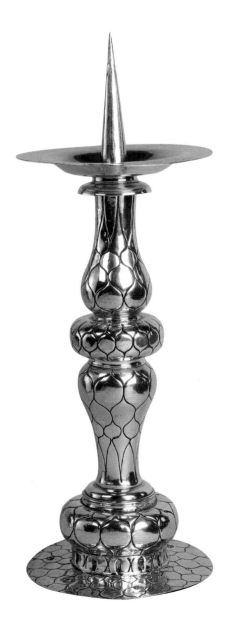

Right:
Fig. 173 One of a pair of candlesticks, silver, *c.* 1530
(Canterbury Cathedral)

Front cover:
Altar cross, silver, Alex Brogden, 1999 (York Minster) and
Altar dish, silver-gilt, c. 1660, unmarked (St George's Chapel, Windsor)

Back cover:
Processional cross, silver and wood, Tony Laws
and Ron Stevens, 1962 (Coventry Cathedral)

All items in photo captions are hallmarked in
London except where stated otherwise